M000006968

IMAGES
of America

EASTON

IMAGES
of America

EASTON

Laurence G. Claggett

ARCADIA
PUBLISHING

Copyright © 1999 by Laurence G. Claggett
ISBN 978-0-7385-0171-0

Published by Arcadia Publishing
Charleston SC, Chicago IL, Portsmouth NH, San Francisco CA

Printed in the United States of America

Library of Congress Catalog Card Number: 99-62792

For all general information contact Arcadia Publishing at:
Telephone 843-853-2070
Fax 843-853-0044
E-Mail sales@arcadiapublishing.com
For customer service and orders:
Toll-Free 1-888-313-2665

Visit us on the Internet at www.arcadiapublishing.com

CONTENTS

Acknowledgments

The four major reference books used as sources of information in the captions are:

The History and Directory of Easton, by George C. Garey; published by S. Ellwood Patchett, 1881.

The Easton Album, By Norman Harrington, published by The Historical Society of Talbot County, 1986.

Where Land and Water Intertwine, by Christopher Weeks; published by the Johns Hopkins University Press, 1984.

Historic Easton, by Cynthia Beatty Ludlow, author; David Reed Freeman, editor; published by Historic Easton, Inc., 1979.

Credit must go to my wife, Lorraine, who spent hours on the computer. Her endeavor straightened my grammar, spelling, and the general readability of the text. She also helped as editor and proofreader.

Also credit should be given to Michael Luby for graciously making his extensive collection available to me; and to Robert G. Shannahan for check-reading, editing, and lending an important postcard. To a lesser degree Charles E. Wheeler, William C. Hill, and Donald Casson helped with minor points in the captions.

INTRODUCTION

In 1711, Talbot County, recently restructured in size and boundary, needed a new county seat. The committee chosen to decide upon its location soon had a big problem on its hands. Groups from divergent directions competed vigorously for the honor of locating the county seat in their area. Among them were a Wye River (Lloyd family) group, partisans from Dover Neck, Betty's Cove (at the pincushion near Todd's Corner Road) adherents, and the Oxford advocates.

The site chosen was none of these. It was a remote old field near Pitt's Bridge, "Armstrong's Old Field," that had been cultivated and abandoned by Native Americans and was riddled with stumps from their girdling of trees, which cleared the forest for farming. A 6-foot wide "Great Road" passed across the east side of the 2-acre plot (a road destined to be widened to 20 feet within five years time). One would think that a site with access to the river would have been selected; but the committee in its wisdom, and with manifest impartiality, decided upon the geographical center of the new county.

The courthouse was completed in 1712. Within a year or two, a jail, pillory, stocks, whipping post, a race track, and several taverns surrounded this building, attesting to the mores of the citizenry. In the town, real growth was painfully slow. It was in the countryside that tobacco farming on large and small estates, patented to settlers by the Lord Proprietor, accumulated wealth, and it was there that the numerous estuaries of the Chesapeake Bay provided avenues for commerce. The Revolution in 1776, however, brought a sweeping change.

A new courthouse was built on the site of the first. A surveyor laid out an organized plan for the town, and now the generic name, Talbot Courthouse, was changed to Easton. Businesses arrived.

In the early 1800s, the row of Federal-style buildings along Washington Street was constructed. Parallel to this, Harrison Street was established with such spacious homes as the Edmondson House (now the Grymes Building), the Bullitt House, and the Hambleton House (now apartments). These impressive buildings attested to the prominence and industry of the new town.

After this initial spurt, the county's growth again slowed. Even such momentous events as the advent of the steamboat in 1830 and the coming of the railroad in 1869 brought but small changes. In fact, the population, decreasing slightly from 1880 to 1900, remained at about 20,000. This was true generally of the whole of the Eastern Shore of Maryland, which dangled like an unused appendage from the booming New York to Washington commercial corridor.

The pace of living began to pick up around 1900. Improved roads and vehicles allowed the widespread country population to come to town and gather around the courthouse block. Wagons, carts, and later, cars and trucks, arrived early Saturday to get a good parking place. People stayed all day and into the night. Friends and relatives met, walked around the block, and discussed family, weather, and crops. Bonds were formed.

Traffic, as well as behavior, were controlled by the chief of police and his deputy. Back in the 1930s, Chief of Police Wood could be seen riding around town on his bicycle with one pedal

missing, keeping the peace. On Saturday night, both the chief and his deputy were on duty.

About 1910, underground sewer lines were completed. Paving and curbing improved the streets, and automobiles soon arrived. The healthy country smell of manure gradually disappeared.

The postcards in this book reflect that early time and the coming of the mechanized age. They are dated from about 1905 to 1940. Most were published by Robson Bros. Stationery. The brothers were in business, first on Washington Street, then on Goldsborough Street, for almost half a century. Ownership changed several times from the 1930s until Bob Rowens eventually bought the store and moved back to Washington Street.

The other named cards were printed and published by E.W. Norman, an Easton photographer. Norman traveled around the Shore plying his trade, at a time most other photographers remained close to home taking pictures of local residents.

In the manner of postcards, scenes are depicted idyllically with maintained buildings, tree-lined streets, and manicured residential areas.

This was the golden age of postcards. Albums were always in evidence in the parlor of the library table of homes to remind family and guests of trips and greetings. After 1940, telephones and telegraphs, and, at the end of the century, e-mail obviated the penny postcard.

Older citizens will enjoy the nostalgia of looking over the days of yore, and younger generations will get a glimpse, although rose-colored, of Easton in a by-gone era.

One

The Courthouse Square

Before there was Easton, the Talbot Courthouse stood atop a slight rise above Pitt's Bridge, occupying the spot around which a town would grow. The courthouse as it is pictured in these postcards was erected in 1794, but it is actually the third one for Talbot County. Its cost of 3,000 pounds sterling was mostly paid by the state, which intended it for state proceedings on the Eastern Shore in alternate sittings with court in the capital. The building in the new Federal style of architecture remained much the same in appearance, despite a remodeling of 1898, until the mid-20th century. At that time, plans to enlarge it were hotly argued, and the decision to add wings attached by hallways was a compromise which, while retaining much of the original, lost the symmetry and framing of the open courtyard space.

The Courthouse Square also encompassed the Music Hall, built in 1879 to be both a commercial and cultural center of town life. A group formed the Town Hall Company, determined to combine the new market with a much-desired place for entertainment. Money was raised to build the first hall, which burned within eight years, and the second one, which is the subject of the postcards. Practically abandoned in the 1920s, it emerged in 1930 as the Music Hall Theater, or "scratch house" as the local youth liked to call it. David Selkow's store was at street level.

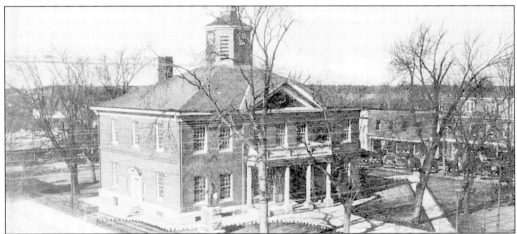

THE COURTHOUSE. After 1915, small boxwood, which are today shoulder high, were planted to outline the borders and walks around the courthouse yard. The survival of the boxwood plantings was at first in question, since kids loved to roller skate around the patterned maze of cement walkways.

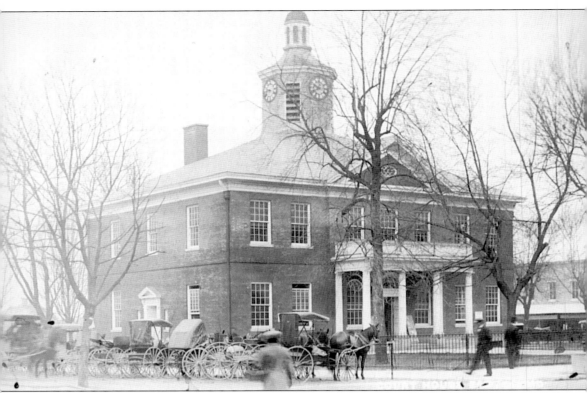

THE COURTHOUSE. The essence of the original building, erected in 1794, survives in this building, pictured in 1905. The facade of brick laid in Flemish bond, originally five bays wide, was enlarged to seven bays in the major remodeling of 1898. The older courthouse of 1712 was the setting for many public protests of the hated English Stamp Act. The court refused to hold the session of November 1765 so that its papers would not be affixed with the obnoxious stamp. The citizenry hung an effigy of the tax collector in the yard to swing "interrorem" until the Act was repealed.

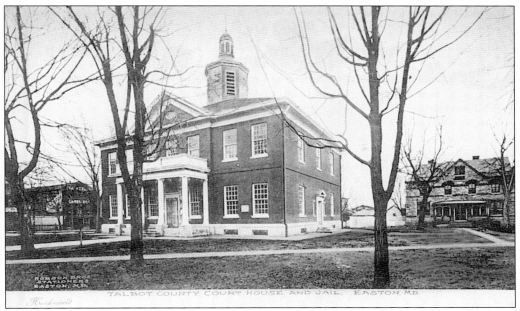

THE COURTHOUSE. This view in winter from the north shows the walkways. In 1898, a town clock was installed in the octagonal cupola as a gift from the people, and it still peals the hours. The clock's maintenance was the job of Oscar F. Sturmer, Easton's longtime jeweler.

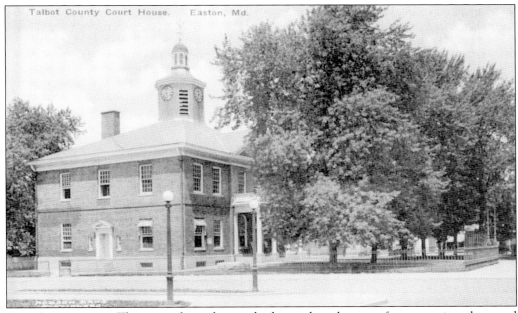

THE COURTHOUSE. This view from the south shows that the iron fence continued around the property, making a tall square archway leading to the front walkway. The plinth for the Confederate Monument was in place; but not the statue, dating the photograph before 1915.

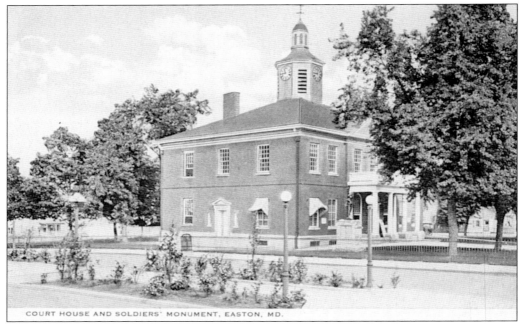

COURT HOUSE AND SOLDIERS' MONUMENT, EASTON, MD.

THE COURTHOUSE AND SOLDIER'S MONUMENT. By 1915, the monument of a Civil War soldier was completed. There was as yet no boxwood around the courthouse itself, but a garden bloomed in a center strip before the Music Hall.

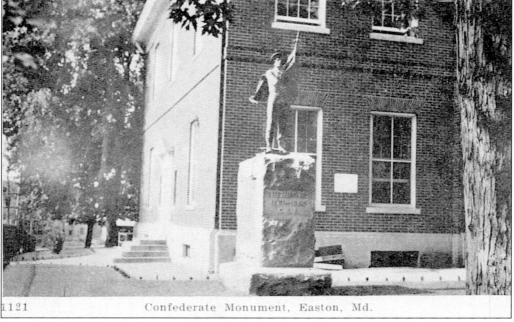

1121 Confederate Monument, Easton, Md.

THE CONFEDERATE MONUMENT. Although the local people were divided on the issue of the Civil War, the preponderance of sympathy among the citizenry, especially of Easton, was with the South, and so the Monument depicts a Confederate soldier. It is inscribed: "To the Talbot Boys, 1861–1865. C.S.A."

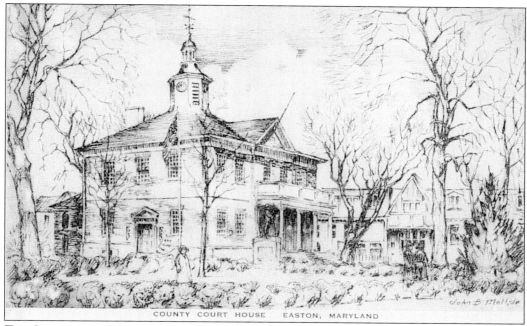

COUNTY COURT HOUSE EASTON, MARYLAND

THE COURTHOUSE. This rendition by artist John B. Moll Jr. placed a hard-to-reach flagpole on the building's pediment, while another flag waved near the southeast corner.

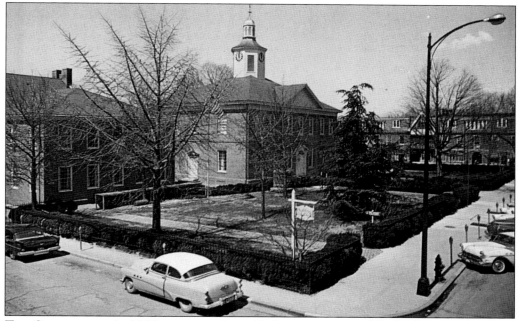

THE COURTHOUSE. In 1958, an expansion added wings connected by hyphens to the north and south of the building and removed the columned portico. Market Street and its plaza were gone, and the old Music Hall had become the public library with an entrance on Dover Street, formerly Court Street.

13

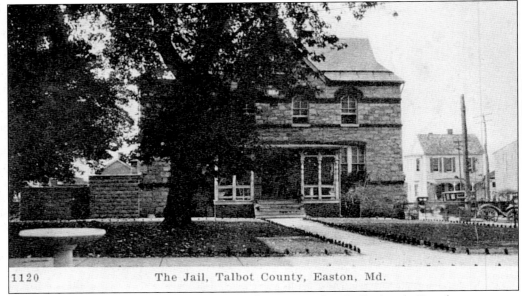

1120 The Jail, Talbot County, Easton, Md.

THE JAIL. Built in 1881, this was the Talbot's second jail. Frederick Douglas was once incarcerated in the first one for helping slaves to escape. The jail also housed the sheriff and his family, who cooked for the prisoners. The fate of the building, considered unsightly by some, has been a matter of controversy since the construction of a modern detention facility.

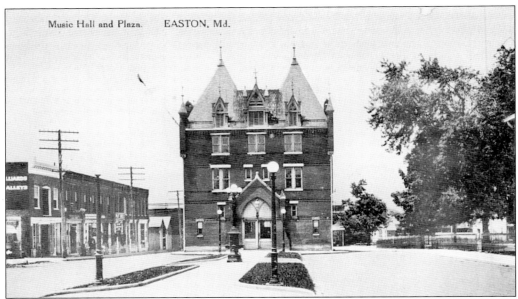

Music Hall and Plaza. EASTON, Md.

THE MUSIC HALL AND PLAZA. The Music Hall no longer exists, but the building of 1879 stands here pictured in isolated majesty. An unusual building with neo-Gothic influences, it held stage productions, musicals, and vaudeville in the second floor auditorium and had a market on the ground floor. The hall was equipped with hanging gas chandeliers, a stage, dressing rooms, and seats for six hundred, half of them chairs. After the musical, one could play billiards or bowl across the street.

14

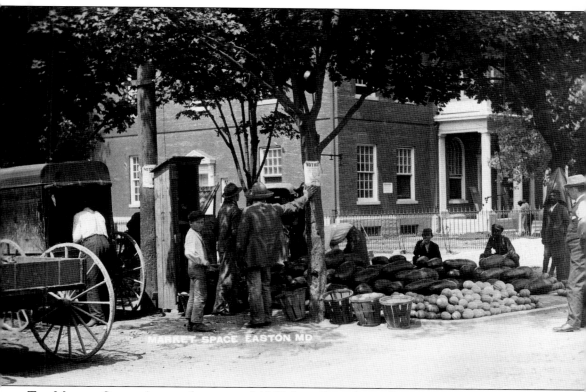

THE MARKET SPACE. A scene from around 1905 shows how the mall in front of the Music Hall was filled each Saturday with melons from Caroline County. Local farmers hawked produce from the backs of their wagons. The slim wooden structure was supposedly Easton's first telephone booth.

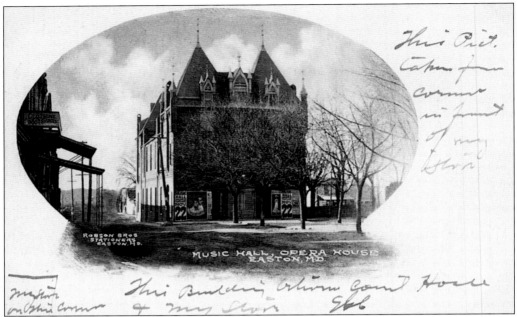

THE MUSIC HALL OPERA HOUSE. This unusual keyhole card is dated 1905. The playbills indicate a performance on November 22, and posters advertise the event. In 1875, an Easton Mozart band occupied a room in the building, which was floor-covered with Brussels carpet and contained an elegant instrument case lined with velvet for their new German silver instruments. B.E. McHale was the band leader.

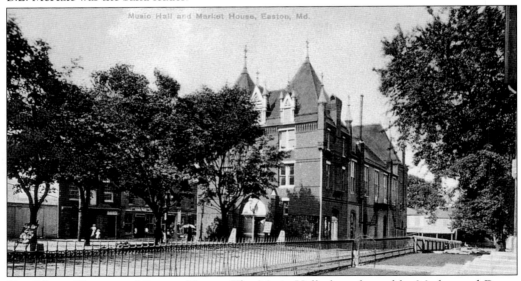

THE MUSIC HALL AND MARKET HOUSE. The Music Hall plaza, formed by Market and Dover Streets, has grown a canopy of trees. The edifice was erected after the fire of 1878 destroyed the first attempt to gain a cultural center for Easton. The Easton Town Hall Committee, incorporated by Dr. H.T. Goldsborough, R.B. Dixon, Thomas Hughlett, P.T. Kennard, and A.A. Townsend, took up subscriptions for both efforts. The three-story brick building with its slate roof of peaks and minarets cost nearly $12,000.

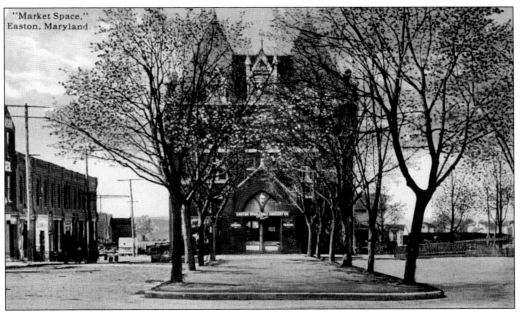

THE MARKET SPACE. In this card, the ground floor was occupied by the Easton Wholesale Grocery Company. Market Street on the right went through to West Street.

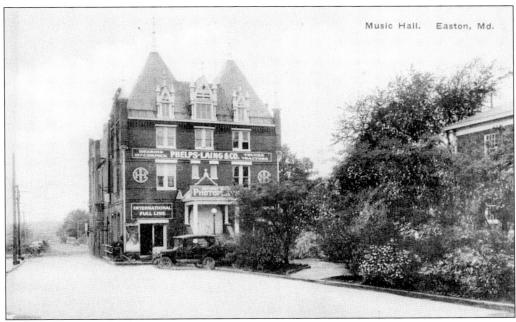

THE MUSIC HALL. Modern entertainment had arrived, indicated by the sign reading 'Music Hall Photoplays.' Among other commercial enterprises occupying the building was a farm equipment business. The round embellishments on either side are the logo of International Harvester. The Phelps Laing & Co. also sold a full line of Deering and McCormick trucks and tractors.

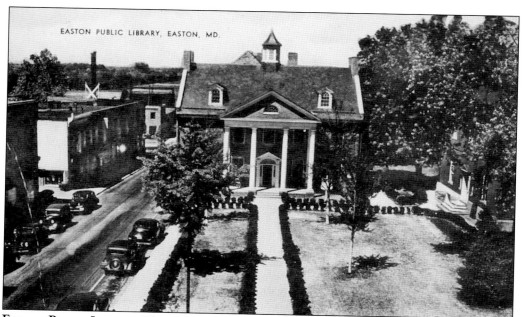

EASTON PUBLIC LIBRARY, EASTON, MD.

EASTON PUBLIC LIBRARY. The old Music Hall is almost unrecognizable in this 1940 remodeled building with its more modest roof-line, new entrance, and integrated boxwood plantings. Just a ghost of old Market Street haunts the north side of the new Talbot County Free Library. The board of education and health department were also housed in the building.

EASTON MUSIC HALL THREE NIGHTS Thursday, Jan. 23rd	Thursday Night Ladies Free	PRICES
CULHANE'S Comedian IN High Class Plays and Vaudeville	On Thursday night every Lady accompanied by a person, (Lady or Gent) holding a paid 30cts. ticket will be admitted free and entitled to Best Reserved Seat Free, in order to obtain this concession. Free tickets must be secured at Moreland Pharmacy, before 6 p. m., on Thursday, January 23rd.	10 20 & 30
	Opening Play-THE STRAIGHT ROAD	CENTS.

ADVERTISING TICKET. These items were distributed about town to insure a full house.

Two

WASHINGTON STREET

Washington Street runs north-south through the town, approximating the path of the early road crossing Pitt's Bridge and the Native American fields. The courthouse was situated along this route. The street has served as the center of the town's commercial and cultural life, and the town's earliest buildings stand here. The urban brick row-houses held businesses on the first floor and offices or living quarters on the second and third floors. Every room was rented.

The selected postcard scenes date from horse-and-carriage days to the advent of the automobile. Around 1920, the ground-floor businesses in the block opposite the courthouse consisted of two banks, two or three grocery stores, two drugstores, two or three soda fountains, one hardware store, two automobile and carriage dealerships, the post office, and a five and ten cent store. From this block the town began to spread south on Washington Street and eastward on Dover and Goldsborough Streets.

Over the years storefronts were modernized, small-paned sash windows replaced with plate glass, cornices boldly bracketed, and roof lines altered; yet the features of the original buildings can be seen in those of today. The large awnings so prominently featured over storefronts served to keep the dirt sidewalks dry during rainstorms. The uncovered streets of dirt, however, were a different matter and frequently turned to mud.

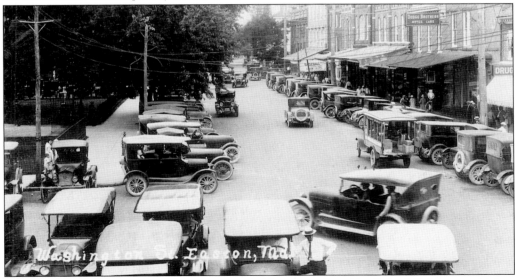

WASHINGTON STREET, 1920. This scene is probably a Saturday with all the folk in town visiting. Cars are parked heading out on the west side of the street for better sight-seeing. Notice the forerunner to the family van in the right foreground and the early compact, or coupe, just ahead of it. The traffic flowed with some nonchalance. The marquee announced a baseball game at Federal Park—Easton vs. Seaford.

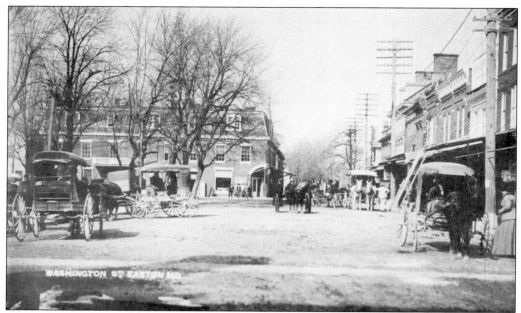

WASHINGTON STREET, 1905. This view looks north with the courthouse unseen at left. On the corner was the Stewart Building with the Moreland Pharmacy sign displayed. This Federal-style building was erected in 1810 by Samuel Groome, and it was known for many years as the Brick Hotel to distinguish it from the Frame Hotel across the street. There were no curbs or gutters, and the woman in a long skirt was about to step into a street of oyster shell, dirt, mud, or worse. Nobody seemed in much of a hurry.

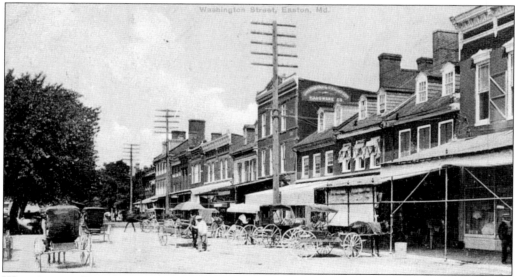

WASHINGTON STREET, 1905. Rotating about 30 degrees eastward, this view shows most of the main business section. The Shannahan and Wrightson Hardware Co., the tallest building in mid-block, was situated with its entrance exactly opposite the courthouse door. Beginning at the corner of Dover Street to mid-block, the businesses were: Robert Dixon's offices, Thompson & Kersey Dry Goods, and Mordecai and Elias Dawson's pharmaceutical store.

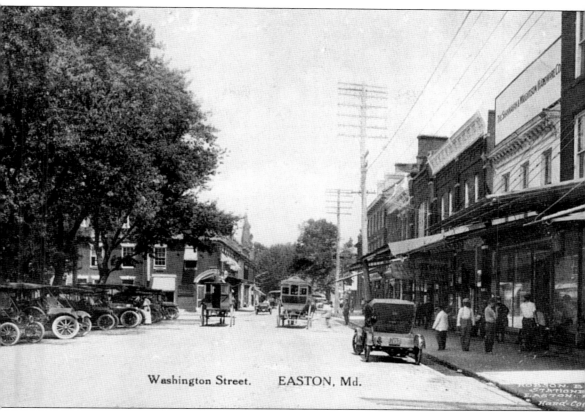

Washington Street. EASTON, Md.

WASHINGTON STREET C. 1915. Ten years later, automobiles were omnipresent and the street smooth and curbed. Underground sewers were in place. Cars parked perpendicular to the curb, but only in front of the courthouse. Traffic still appeared slow and unorganized. Notice the two wagons going side by side in the same direction. The new Shannahan & Wrightson Hardware Co. sign obscured two dormer windows.

21

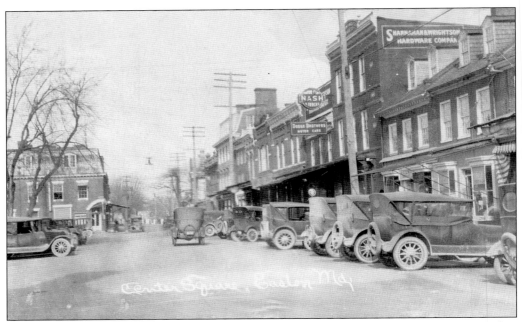

WASHINGTON STREET, C. 1918. The parking pattern remains the same as that on page 19, but there were no carriages in sight. Shannahan & Wrightson Hardware Company sold Nash and Dodge cars where it previously had sold Oldsmobiles and Buicks.

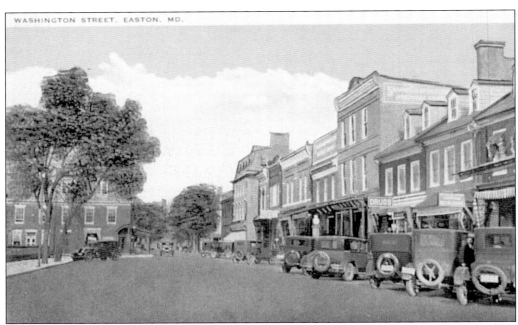

WASHINGTON STREET, EASTON, MD.

WASHINGTON STREET IN THE LATE 1920s. The cars are now all parked heading in on the diagonal, but the 'streetscape' is virtually unchanged. The gas-pump on the curb in front of the Shannahan & Wrightson building was needed to sell fuel to its gas-driven farm equipment and the hottest item—automobiles.

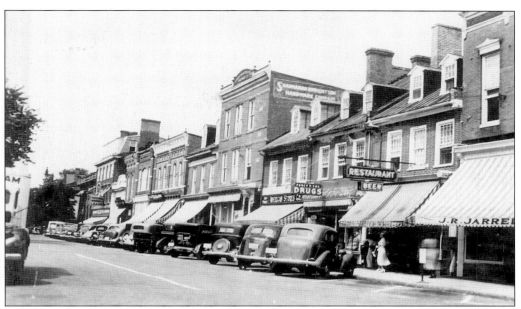

WASHINGTON STREET C. 1930. A few years later the parking pattern was the same, but the street has been lined and the gas-pump gone. J.R. Jarrell replaced Thompson & Kersey as a clothing and dry goods store, next was the Puritan Restaurant (selling beer), the Richard J. Trippe pharmacy, and the American Stores grocery—precursor to Acme.

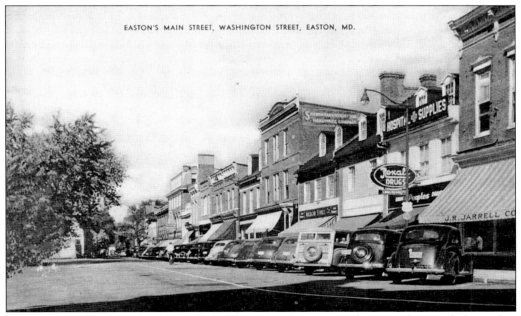

WASHINGTON STREET, AROUND 1936. The street has acquired streetlights, and the utility poles are gone. The Route sign on the nearest pole reads 213—the oldest road northward up Maryland's Eastern Shore. Stahlhut's Peoples Drug Store had replaced the Puritan Restaurant by the time of this card.

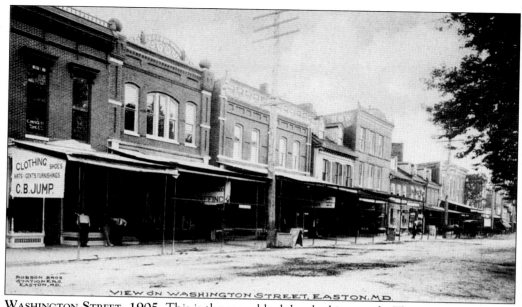

WASHINGTON STREET, 1905. This is the same block but looking south. The names on some of the establishments identify C.B. Jump's men's clothing store, which previously had been John Jump's Emporium and Chaffinch's store for general merchandise. Jump's was a large three-story building originally built by Owen Kennard that eventually became McCrory's store. Intricate grillwork and roof embellishments adorn the old Federal buildings.

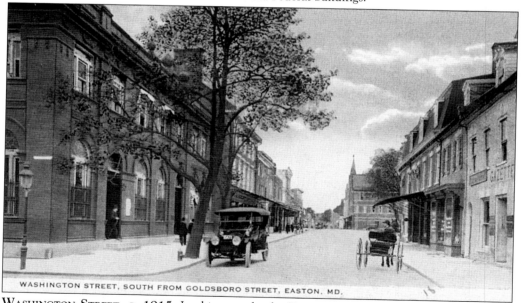

WASHINGTON STREET, C. 1915. Looking south, the Easton National Bank building is on the corner of Goldsborough Street. On the right is the office of the *Easton Gazette*, founded in 1817, and described in 1881 as "always an advocate of free schools and free education . . . during the war it sustained the side of the Government with energy and spirit, and now advocates the principles of the Republican party." Wilson M. Tylor edited and published the weekly newspaper when this card was made.

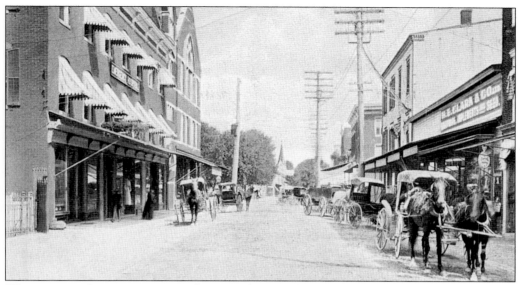

WASHINGTON STREET, 1905. Looking north toward Dover Street, the facade of the Odd Fellows Hall with finial shaped as an open hand is where the Miller Lodge Number 18 has met since 1893. In 1906, John Mason leased the two upper floors of the Avon building in the foreground as an "Emergency Hospital" to establish Easton's first hospital. Across the street, the tall building and the H.E. Clark & Co., selling hardware, implements, and seed, were on the site of the future Thompson Park.

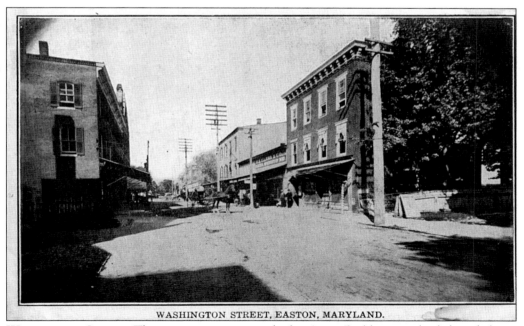

WASHINGTON STREET, EASTON, MARYLAND.

WASHINGTON STREET. The same view starts with the Avon Building on the left and shows on the right the large building owned in 1851 by Easton attorney John C. Goldsborough, and afterward by his son Henry. It was used as Thomas Nichols' hardware store for a time, owned by Jacob Wheatley in 1904, and then by T. Earl Ewing.

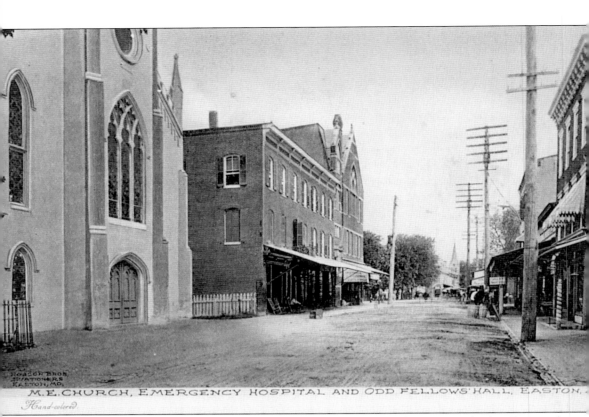

M.E. CHURCH, EMERGENCY HOSPITAL AND ODD FELLOWS' HALL, EASTON,

Hand-colored.

WASHINGTON STREET, LOOKING NORTH. Tilting westward, the Ebenezer Methodist Episcopal Church, built in 1856, comes into view in the foreground followed by the Avon Building and the Odd Fellow's Hall. The Calvary Methodist Church steeple is visible in the far background. Across the way, a barbershop pole stands in front of the Goldsborough property. The wheel-tracked road, the barrels in the street, and rocking chairs under awnings all speak of life moving at a slower pace.

Three

OTHER EASTON STREETS

As the town grew, it expanded eastward from the courthouse. Businesses and shops established themselves along the streets that formed the block enclosed by Harrison, Dover, and Goldsborough Streets. Paralleling Harrison to the east were Hanson and Aurora Streets, while Bay Street, South Street, and Brooklets Avenue were east-west axes aligned with Dover Street. This nucleus of streets is represented by the postcards of this chapter.

Eventually, a smaller business district known as East End developed on Dover Street beyond Aurora Street. Adjoining the business district, the more prosperous built spacious homes framed by the tree-lined corridors of Goldsborough, North Aurora, Harrison Streets, and Brooklets Avenue. Such influential town leaders as James Bullitt, Maryland Governor Philip Francis Thompson, Isaac Powell, Dr. I.L. Adkins, Charles T. Wrightson, Thomas Hughlett, Dr. H.T. Goldsborough, Owen Kennard, U.S. Senator John Leeds Kerr, Dr. Samuel Harrison, Dr. William T. Hammond, and Wilson M. Tylor lived in town. Large churches for the Methodists, Episcopalians, and Catholics were erected in these neighborhoods.

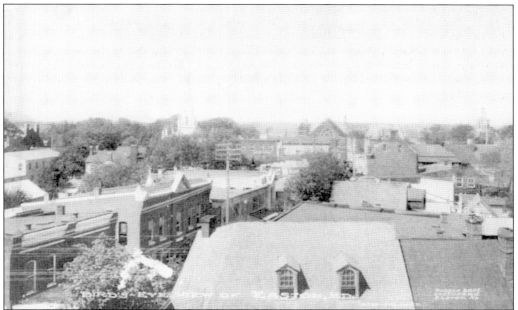

A BIRD'S-EYE VIEW. This looks from the cupola of the Avon (Norris) Hotel on Harrison Street. In 1910, a sea of hip-roofed buildings lines Dover Street up to Washington Street where the courthouse clock cupola is visible at top far right. The steeple on the far left is that of the Ebenezer Methodist Episcopal Church (now the Historical Society Auditorium).

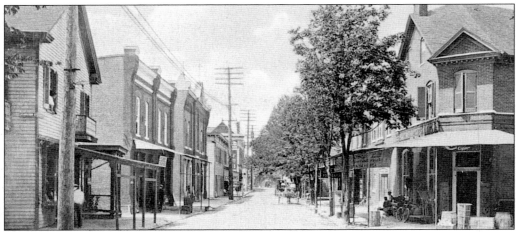

DOVER STREET, LOOKING WEST FROM HARRISON STREET. Around 1906, the street is much narrower than today. Except for the wooden building on the left, which is the site of the present Avalon Theater, the streetscape is much the same. The first brick building on the left was built in 1879 by Alphonse Townsend. The second brick building is enriched with iron cresting on the roof and a pediment with a weathervane. Since 1945, four generations of William D. Hill's family have practiced pharmacy there. The house on the north corner, now known as the Grymes Building, is an old Federal structure that has been greatly altered. Built in 1794 by Pollard Edmondson for his daughter Lucretia, it served as her home and that of her daughter, who married a Wallis, of the Duchess of Windsor's family. Later residents were James Bullitt, Philip Francis Thompson, Isaac Powell, and William Reddie, second president of Talbot Bank. The home once had a carriage house, gardens, and handsome columned entrance on Harrison Street.

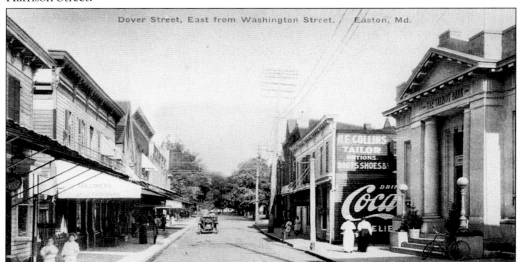

DOVER STREET, LOOKING EAST FROM WASHINGTON STREET. In this 1915 card, the south side of Dover Street shows little change from the earlier scene, except for curbs and sidewalks. The road remains unpaved. Businesses on the left include a tailor and milliner. The building with columns and pediments on the right is the Talbot Bank. The H.E. Collins building was torn down to make a drive-thru for the Talbot Bank and a parking lot for Hill's Drugstore. The trees have come down.

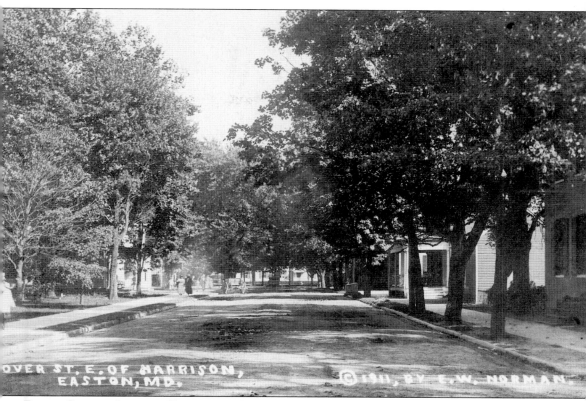

DOVER STREET, LOOKING EAST FROM HARRISON STREET. A tree-lined Dover Street of 1911 sports curbs and sidewalks with grassy strips for leisurely strolling. The trees grow on the street side of the curbing. In shadow on the right is the Bullitt House, across from the hotel. Next door, Dr. J.M.H. Bateman's house, with protruding porch, was removed for a garage and used car lot. Now the site is a parking lot.

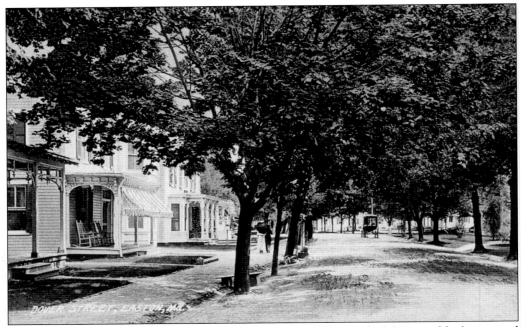

DOVER STREET, LOOKING EAST FROM HARRISON STREET. This card of the next block eastward gives a closer look at the homes with rocking chairs on the front porches. The carriage mount placed over the gutter was a necessity on muddy streets. The house with the awning belonged to R.L. Kemp.

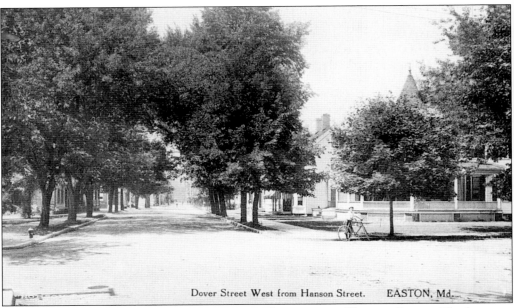

Dover Street West from Hanson Street. EASTON, Md.

DOVER STREET, LOOKING WEST TOWARD TOWN CENTER FROM HANSON STREET. The boy on a bicycle is in front of the handsome Fleckenstein home with its ample porch. The house was torn down and replaced by the modern Shireton Condominiums. At this time the curbing encloses the trees.

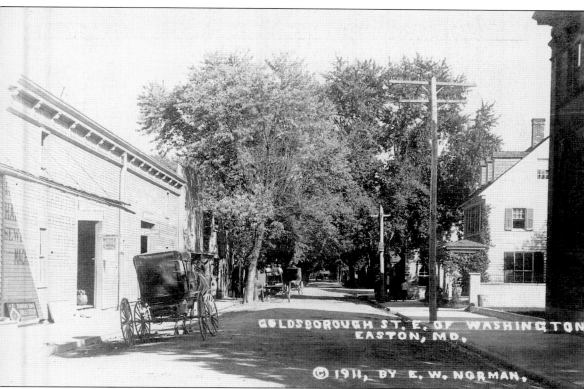

GOLDSBOROUGH ST. E. OF WASHINGTON
EASTON, MD.

© 1911, BY E. W. NORMAN,

GOLDSBOROUGH STREET, 1911. This is a rare card showing the shadow of the Easton National Bank at the right and Nevius & Frampton Hardware Company on the left. Some of the words on the wall of that simple weather-boarded structure say "Sewing Machines" and "Harness." Simon Nevius and Charles Frampton started their business in 1899, and it was carried on by Ron and Carl Nevius for most of the 20th century in the same way and behind the same wooden counters and clutter of drawers, boxes, and barrels. Purchases were tied up with brown paper and string. The building had existed since the early 1800s as a hotel and tavern, operated by its builder, David Kerr, and then by Ennals Rozell, who called it the Union Tavern. The next owner was a Southern sympathizer, and when he went insolvent, Thomas Haddaway took over and diplomatically called it the Frame Hotel, shifting attention from political history to a more neutral architectural feature.

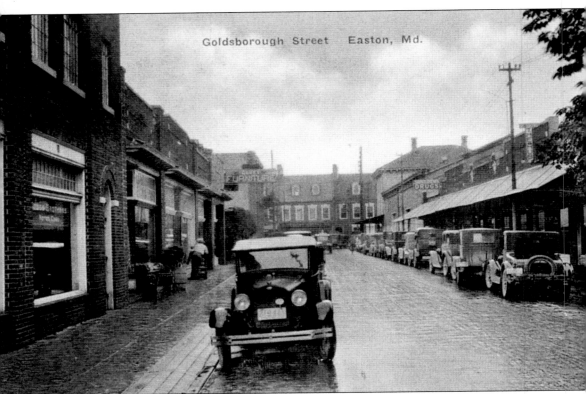

Goldsborough Street Easton, Md.

GOLDSBOROUGH STREET, LOOKING WEST FROM HARRISON STREET. In 1930, the commercial nature of the block is evident. Among the businesses were Dodge Brothers Motor Cars, Garey Furniture, People's Cut Rate Drugstore, and The Hub men's store. The Nevius & Frampton store still has the hipped roof it was to lose in the fire of 1950. A glimpse of the row of windowed buildings in the background shows two of the finely proportioned homes that were among the earliest in the town. The Thomas Perrin Smith House was built by a wealthy planter, Joshua Clark, and wife Ann, who purchased the plot in 1759. Smith, editor of the *Republican Star*, bought the land in 1801. The *Gazette* was published here, and in 1912, the building became the home of the Chesapeake Bay Yacht Club, ironically a yacht club with no water anchorage. Cars parked along the busy street where formerly trees grew, the roadway had been widened and paved with brick.

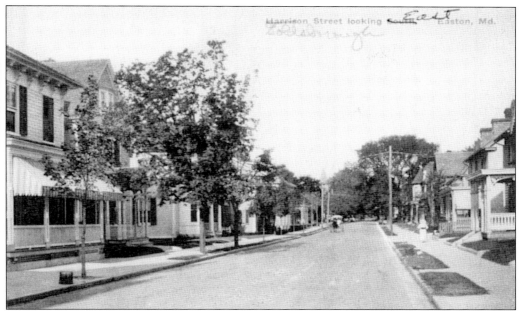

GOLDSBOROUGH STREET, LOOKING EAST. The street became residential and is so today, the homes relatively unchanged. Their mid-to-late-19th-century architecture captured hints of Greek Revival, Queen Anne, and Victorian styles in cornices, windows, gables, and porches. The Sts. Peter and Paul Catholic Church steeple is in the distance.

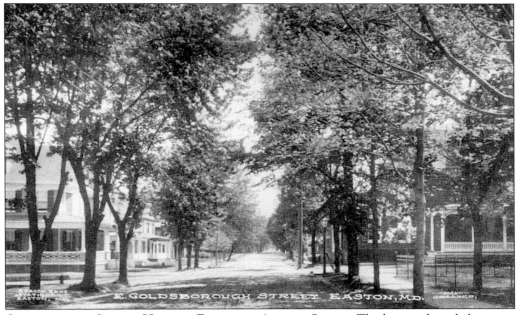

GOLDSBOROUGH STREET, HEADING EAST FROM AURORA STREET. The houses shrouded in trees were the Bishop's House at right and the Nichols' house cater-cornered to it. The first bishop, the Rt. Rev. Henry C. Lay, was the moving force that made Easton a see for the Episcopal church, necessitating the purchase of this 1880 house as a residence for the bishop. W.F. Adams lived here at the time of this card.

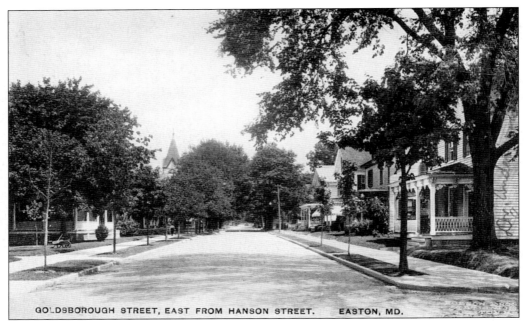

GOLDSBOROUGH STREET, EAST FROM HANSON STREET. EASTON, MD.

GOLDSBOROUGH STREET, LOOKING EAST FROM HANSON STREET. Here is a closer view of the homes leading up to the Bishop's House, with the Catholic Church steeple showing above the trees.

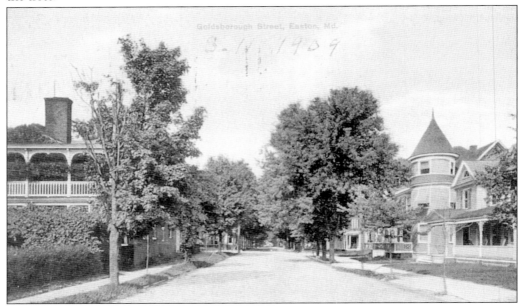

GOLDSBOROUGH STREET, LOOKING WEST. At the corner of Aurora, the second-story porch of Foxley Hall is seen on the left. Built in 1795 by Deborah Perry Dickinson, it is a collage of Federal craftsmanship. The oldest part may be the brick ell at the rear. Dr. Samuel A. Harrison, Colonel Oswald Tilghman, and Harrison Tilghman amassed their private historical library here. The present owner, John White, has faithfully restored it. Across the street, the house with the rounded tower was the Nichols house.

34

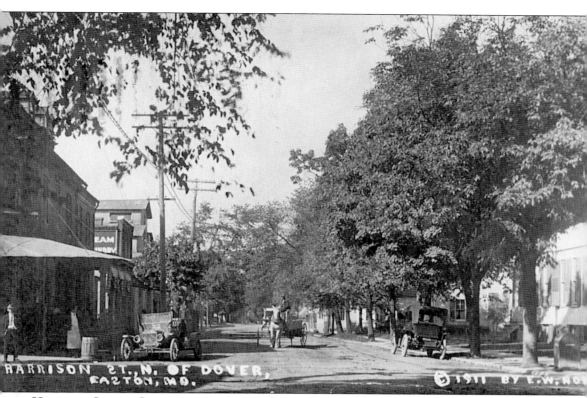

HARRISON STREET, LOOKING NORTH FROM DOVER STREET. This view of about 1911 reveals a roadway with ample room for traffic and parking space on both sides.

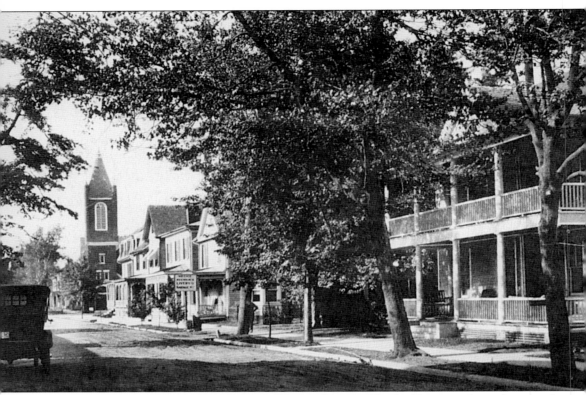

HARRISON STREET, LOOKING NORTH FROM DOVER STREET. The buildings on the right side of the street come into sight in this view. The two-story veranda belonged to the Dunham home, which stood where the Gold Room addition to the Tidewater Inn was built. Down the street was a sign that read "Notice. Seemer's Livery Garage." Farthest distant was the Trinity M.E. Church, South, built in 1876, which no longer stands.

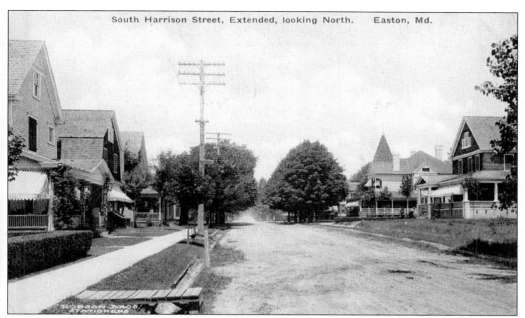

South Harrison Street, Extended, looking North. Easton, Md.

HARRISON STREET EXTENDED, LOOKING NORTH. The homes beyond Brooklets Avenue are virtually unchanged today. The A. Ross house is on the right, next to the Parlett House, now Newnam's Funeral Home.

HARRISON STREET, LOOKING NORTH FROM BROOKLETS. The dirt roadway is criss-crossed with tire tracks, many of them made by the bicycles, which two men are riding here. A third rider talks to a friend in the street. The steeple of Christ Church arises in the distance.

37

Hanson Street, Looking North from Dover Street. This 1911 photograph shows a shady neighborhood of well-spaced homes, which today is crowded by a large apartment building, some business establishments, and ornamental trees.

HANSON STREET, LOOKING SOUTH FROM DOVER STREET. Taken a few years after the curbing was installed, this view includes part of the Wrightson home, at left, with a hitching post on the street. Later, Mayor Francis H. Wrightson installed an early handicap access by the hitching post for his invalid sister. The three old houses on the right were removed for parking at the post office.

AURORA STREET, LOOKING NORTH. This block north of Dover Street was known by the local folk as "silk stocking" row for its well-heeled residents.

AURORA STREET, NORTH FROM DOVER STREET, EASTON, MD.

AURORA STREET, LOOKING NORTH. These elegant Victorian homes, built around the turn of the century, are still a portrait of affluence today. The first house was built by Edward B. Hardcastle.

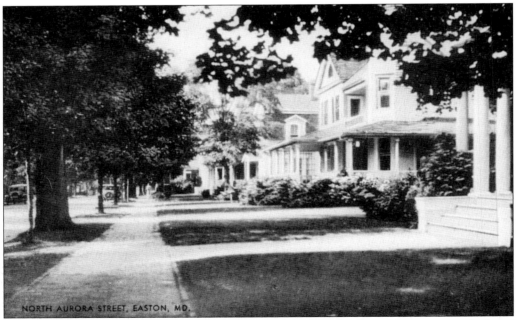

NORTH AURORA STREET, EASTON, MD.

AURORA STREET, LOOKING NORTH. This glimpse of the John McDaniel house, now a bed and breakfast, doesn't do justice to the fine Victorian home. Augusta and Robert Lloyd Tilghman first occupied the property, then the Reverend Henry Lay, the Nickersons, and John McDaniel.

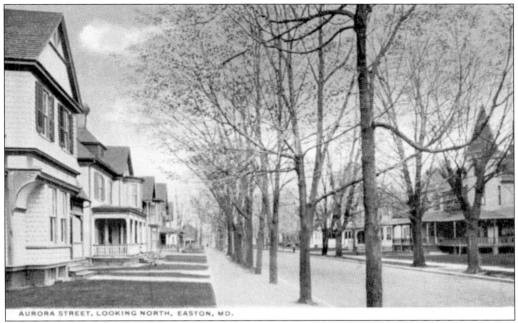

AURORA STREET, LOOKING NORTH, EASTON, MD.

AURORA STREET, LOOKING NORTH. The towered elegance of the McDaniel house is revealed in this winter view. Of the homes at left, the first one has been torn down for new condominiums, but the J.E. Shannahan house next door with its intricately detailed porch woodwork has fortuitously escaped alteration.

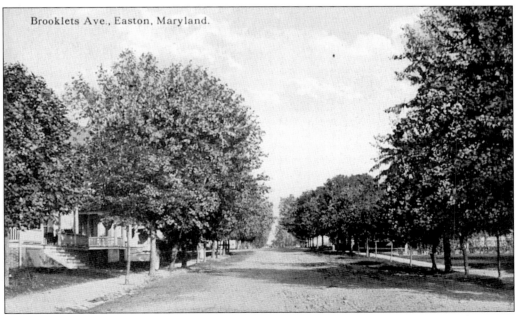

Brooklets Ave., Easton, Maryland.

BROOKLETS AVENUE, LOOKING EAST FROM WASHINGTON STREET. Trees obscured the homes in this early view showing a rutted muddy street.

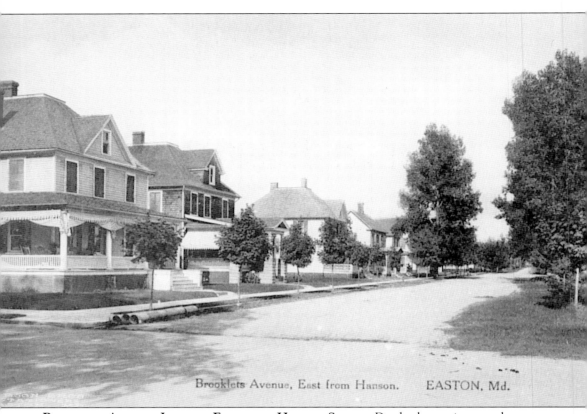

Brooklets Avenue, East from Hanson. EASTON, Md.

BROOKLETS AVENUE, LOOKING EAST FROM HANSON STREET. Do the large pipes on the corner of Brooklets and Hanson Streets indicate that the curbs and storm gutters were then being installed? The view shows a road leading out of town into the countryside. Now the busy lanes of Route 50 pass in that direction.

Four

DOING BUSINESS

The Shannahan & Wrightson Hardware Company was perhaps typical of many Easton enterprises. Tradition has it that a simple forge was operating on the same site in 1711. With the advent of the town, the enterprise evolved into a business selling harnesses and wagons, and by 1901, Oldsmobile and Buick cars. The store at its prime spanned the width of the block with entrances on two streets. After World War II, half the store divided into small shops, while the remainder continued as a hardware business. Today, this last remnant of the company is gone.

The first market in town was established by a legislative act of 1790 and was discontinued by an act of 1801 when a new market on Washington Street was decreed "the proper and lawful market of Easton." The new market burned down twice and was razed once, but the first still stands.

Twenty-five newspapers have had their day since the first was printed in 1790. A descendant of the earliest paper, *The Star Democrat* espoused the politics of the South and the Democratic Party—the popular sentiments of the day; the *Gazette*, staunchly Republican, supported the Union. Under Wilson M. Tylor, it was said that the *Gazette* was "probably the best ever published in Talbot County."

Easton became the financial hub of the Eastern Shore when the first bank outside of Baltimore, the Farmers Bank, opened there. By 1881, the town supported 3 weekly newspapers, 14 attorneys, 11 groceries, 12 sellers of boots and shoes, 9 physicians, 4 hardware stores, 6 general merchandise stores, and 2 hotels.

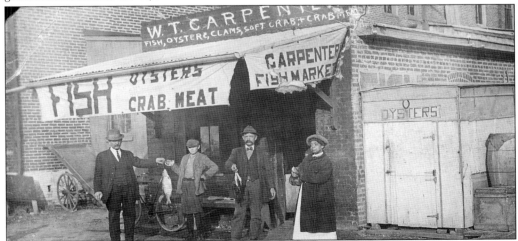

THE FISH MARKET. Mr. Will Carpenter proudly poses in front of his seafood establishment at 4 South West Street with the catch of the day. One little shed is labeled "Oysters." The brick building stands today, but is hardly recognizable. The year is 1905.

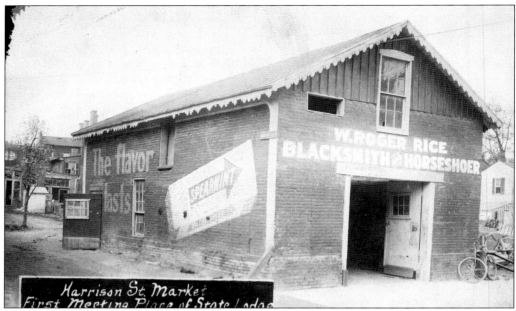

HARRISON STREET MARKET. This card of 1905 depicts the oldest building in Easton of which there is an authentic record. Built in 1791, its roof was fixed on tall piers for good circulation of air. By law, market days were Tuesdays and Saturdays. The loft was used by the first Freemasons Lodge in the state and also for the first non-sectarian Sunday school in town when Methodists, Quakers, and Presbyterians offered it for any child who could get there. In 1880, the structure was J.W. Cheezum's stable and then, as pictured here, Roger Rice's blacksmith shop. The Spearmint gum slogan, "the flavor lasts," could apply as well to this building, which still stands on Harrison Street.

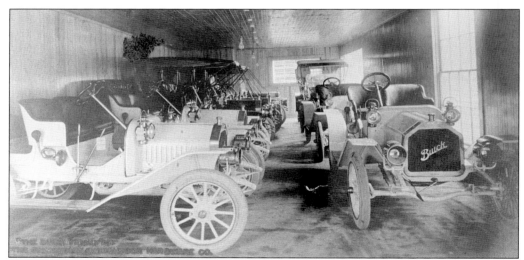

HARDWARE STORE DISPLAY. The postcard is labeled "The Buick Family" and shows a display of cars on the second floor of the Shannahan & Wrightson store. The cars were lifted there by a huge elevator at the center of the building. Notice the early car details of long steering wheels, horns, lanterns and headlights, handbrakes, engine crank, running board, and shock absorbers.

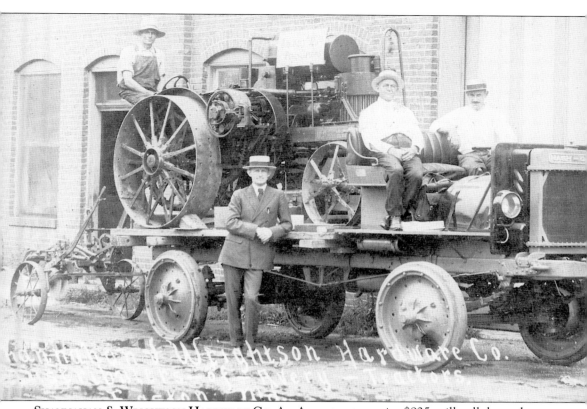

Shannahan & Wrightson Hardware Co. An Avery tractor, price $925, will pull three plows according to the advertising. It sat atop a Nash-Quad flat truck with solid rubber tires. William E. Shannahan stood in front of his merchandise.

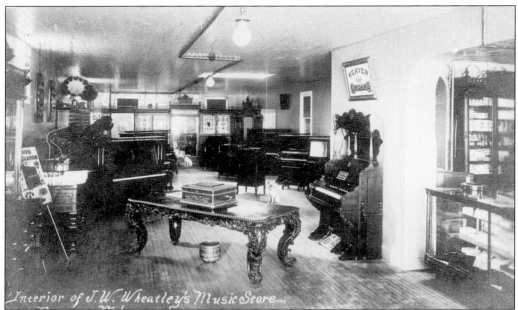

J.W. Wheatley's Music Store, 1907. An interior scene shows displays of Weaver organs and a decorative Regina music box on top of the table. The little dog hearing "his master's voice" indicated that talking boxes were in stock as well. Wouldn't it be a thrill to walk into this store today?

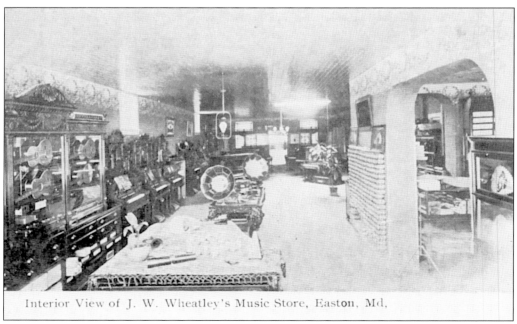

Interior View of J. W. Wheatley's Music Store, Easton, Md.

J.W. Wheatley's Music Store. In 1913, the newer morning glory victrolas sat atop the table that formerly displayed the Regina. Guitars lined a glass cabinet.

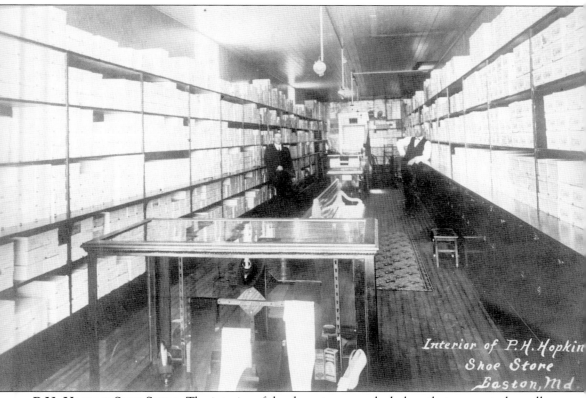

Interior of P.H. Hopkin
Shoe Store
Easton, Md

P.H. HOPKINS SHOE STORE. The interior of the shoe store reveals shelves that appear to be well stocked for a town of four thousand people. The advertisement on the back of the postcard says: "Turn your toes in this direction."

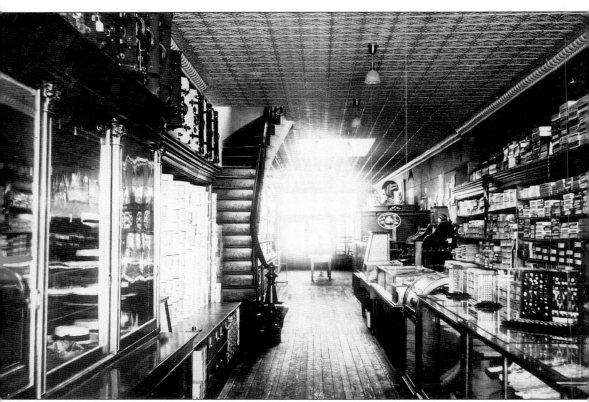

A Tailor Shop. The Brunker and Tarbutton tailor shop on Dover Street used cards such as this, displaying the shop's interior, to mail to potential customers in nearby towns. This card went to the town of Choptank to announce an "opening" at C.T. Perry & Sons for made-to-measure clothes. (Collection of Michael Luby.)

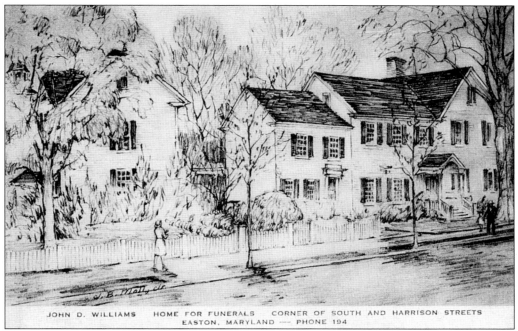

JOHN D. WILLIAMS HOME FOR FUNERALS CORNER OF SOUTH AND HARRISON STREETS
EASTON, MARYLAND — PHONE 194

JOHN D. WILLIAMS FUNERAL HOME. After 1931, the building on the left, the abandoned Academy, was operated as a funeral home and antique shop. The rambling home to the right was formed by joining the residences of Dr. Tristram Thomas and the Hardcastle family. The houses were moved from Dover Street so that the new post office could be erected. Both structures have been incorporated into the Academy of Arts. The drawing is by John B. Moll Jr.

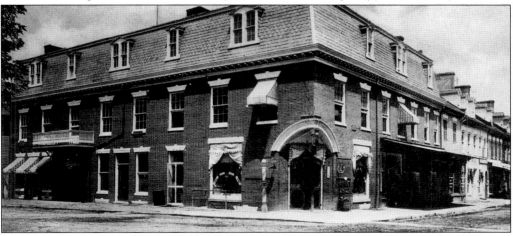

THE MORELAND BLOCK. This and the following two cards show the changing facade of one of Easton's oldest central buildings, built about 1812. After fire demolished the first row of buildings along Federal and Washington Streets, Samuel Groome, a wealthy merchant, acquired the burnt-out property and built this three-story brick structure for a hotel and tavern. Known for many years as "The Brick Hotel," it was also popular for town balls and assemblies. Colonel Sam'l Hambleton changed the roof to the present mansard style in 1853. Its extensive size made it known as the Moreland Block, the main entrance to which was through that of the Moreland Pharmacy.

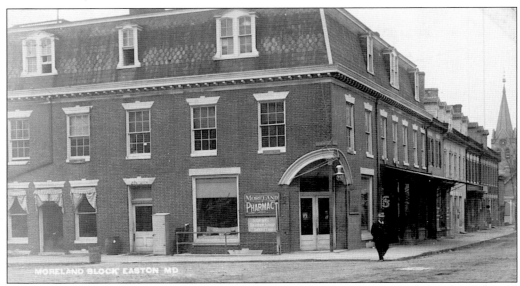

THE MORELAND BLOCK. This card shows a closer view of the architectural details of the old federal windows and new mansard roof. When competition from the new Avon Hotel caused the Brick Hotel to close, the owner, James B. Dixon, rented offices and hoped for boarders. The cut-off corner entrance took the place of a doorway on Federal Street. The Norris Barber Shop is downstairs.

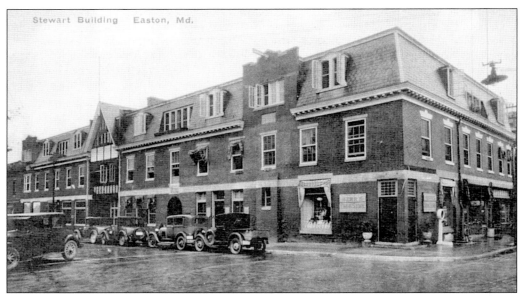

THE STEWART BUILDING. After 1920, Glenn Stewart owned the building, adding Tudor touches of leaded windows and parapets. Kerr's Drugstore, a favorite downtown hangout for young and old, replaced the Moreland Pharmacy and Stam's Drugstore. On the sidewalk stood a penny weighing machine and a cigar Indian; inside was Easton's first nickel pinball machine and a long fountain bar. On special Saturdays, kids could drink their fill of root beer for 5¢. The streetlight hung from wires overhead.

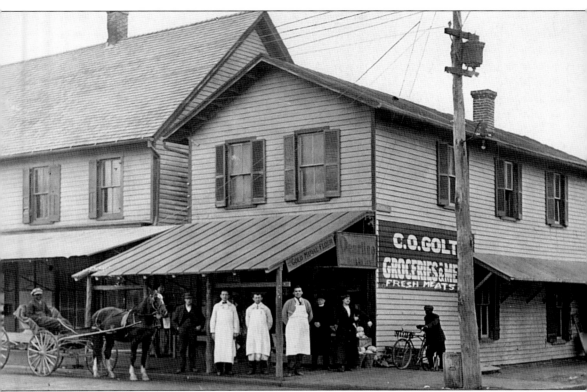

C.O. Golt's Grocery. The staff and customers are posed outside C.O. Golt's store for "Groceries and Meats" on the southeast corner of Aurora and Dover Streets at East End. Golt started his business in January 1910. He advertised that his meats are fresh and that he carried Gold Metal flour and Pearline dentifrice, the "Best by Test." (Collection of Michael Luby)

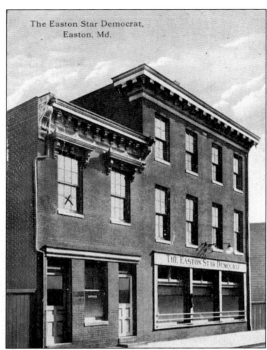

The Easton Star Democrat,
Easton, Md.

THE EASTON STAR DEMOCRAT. Since the town's beginnings, the newspaper has existed under various names and in many locations. Presses rolled in this building, with its handsome bracketed cornices, in 1916 when Dover Street was paved with yellow brick. The X, it is assumed, marks the private office of the editor, Samuel Shannahan.

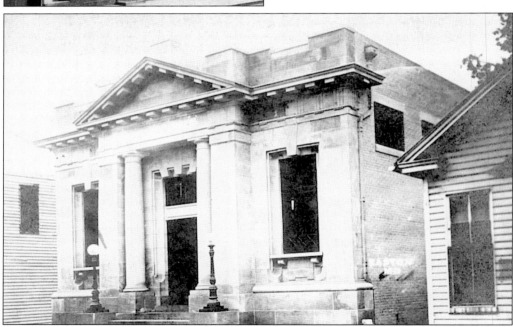

THE TALBOT BANK, 1913. The Talbot Savings Bank, founded in 1885, first occupied the house at the right. Deposits were accepted from 25¢ to $10, but limited to $20 per week. Nevertheless, the bank thrived under President Jerome B. Bennett and cashier William W. Spence, necessitating the building of the present neo-Classical structure in 1908, when it was chartered as The Talbot Bank. William Reddie and his son William served as presidents until 1977.

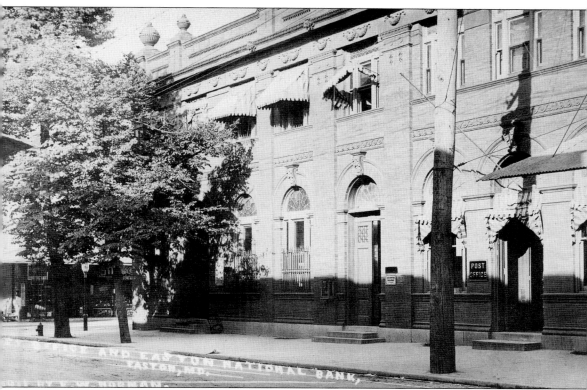

EASTON NATIONAL BANK AND POST OFFICE. The oldest bank in Maryland, and 24th oldest in the United States, it opened in 1805 and for five years transacted all the monetary operations for the entire Shore. John Kennard sold this lot to the bank in 1810, moving his house to another location. The bank's brick building was enclosed with an iron fence, a piece of which has been preserved in front of the bank. The early presidents were Nicholas Hammond, Thomas J. Bullitt, Colonel William R. Hughlett, and Dr. Issac Atkinson.

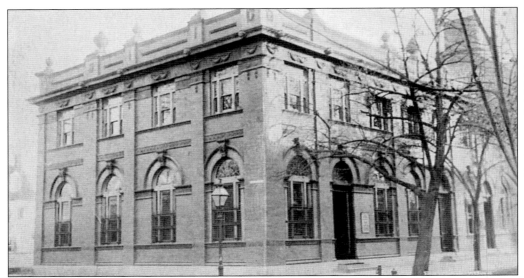

EASTON NATIONAL BANK. In 1857, enlargements were added. President Robert Dixon was followed by his son James Dixon, who in 1903 had the facade remodeled in the fashionable Beaux-Arts classical style. The bank merged with Maryland National Bank in 1962 when J. McKenny Willis was president, and is now the NationsBank. The post office was located here until 1936.

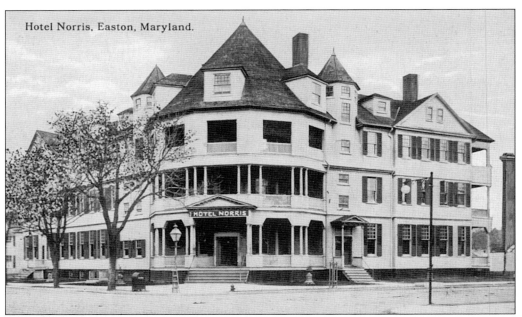

Hotel Norris, Easton, Maryland.

HOTEL NORRIS (AVON). When this large new facility opened in 1893, the Brick Hotel and the Frame Hotel closed their doors. A consortium had acquired Dr. Isaac Atkinson's house and built the commodious Avon Hotel. This area was once the homestead on David Kerr's Longacres farm, the fields of which had gradually become absorbed into the town. The first manager, Colonel James C. Norris, later bought the business and changed the name to Hotel Norris.

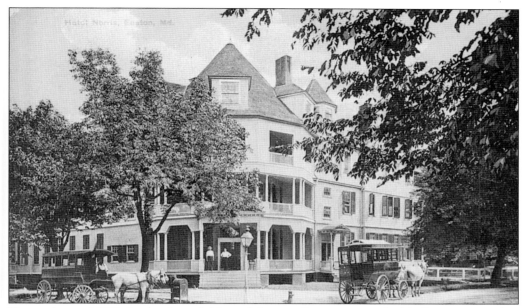

HOTEL AVON, 1905. At the time of this card the omnibus wagons parked in front were used to meet the steamboats at Easton Point and Miles River landings, and the trains at the Baltimore, Chesapeake & Atlantic (BC&A) and Pennsylvania stations.

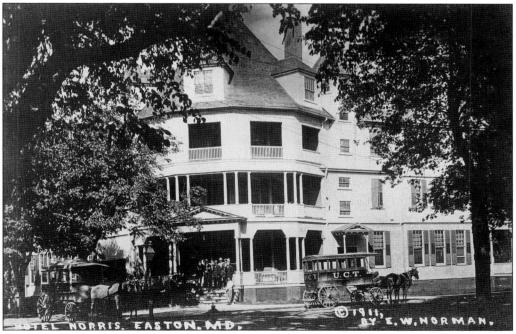

HOTEL NORRIS, c. 1911. Did a group of conventioneers pose for their picture on the steps in this photograph card? An early taxi service was provided by the U.C.T. and Seemer's bus. In 1944, the east wing of the wooden hotel burned, ruining the entire building. Today, the brick Tidewater Inn is located there.

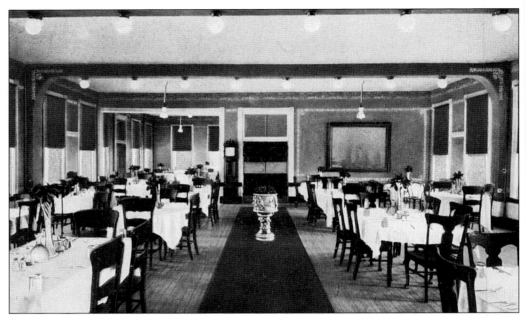

HOTEL NORRIS. The hotel dining room is depicted here in all its elegance. Less formal was the barroom underneath the dining room, which was entered by a step-down on Harrison Street. The bar was a favorite watering hole in the 1920s and '30s when Prohibition was not the law.

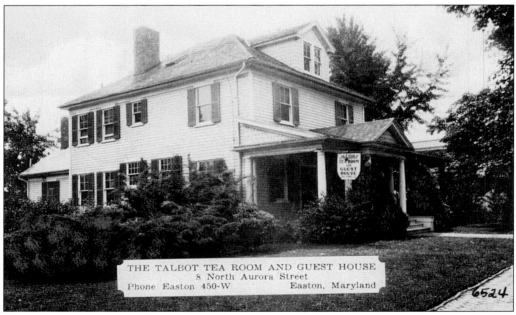

THE TALBOT TEA ROOM AND GUEST HOUSE
8 North Aurora Street
Phone Easton 450-W Easton, Maryland

6524

THE TALBOT TEAROOM AND GUEST HOUSE. This house, located next to the Union Trust Bank on the corner of Aurora and Dover, was demolished to make a parking lot and drive-thru for the bank.

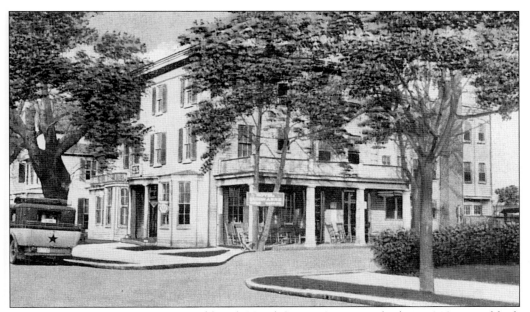

THE HOTEL QUEEN ANNE. A second hotel, Hotel Queen Anne, was built in 1918, just a block east on Dover Street from the Avon (Norris) Hotel. In the card, a Red Star Bus stops for passengers, but no hotel patrons are rocking on the porch chairs.

THE HOTEL QUEEN ANNE ANNEX. Located east of the Queen Anne Hotel, the annex has been converted into apartments today.

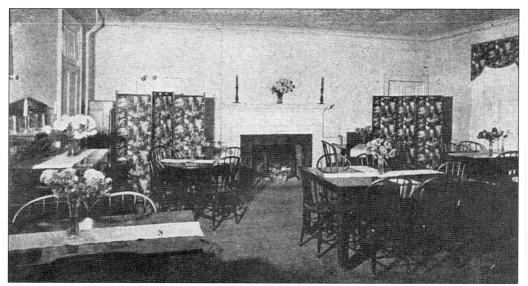

THE TALBOT TEA ROOM. The interior of the tearoom is today the front sitting room of a private women's club, The Harbor Club, on the first floor of the men's yacht club on North Washington Street.

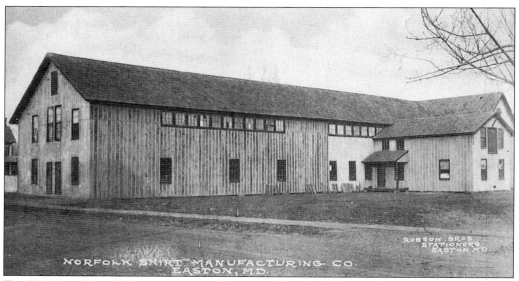

THE NORFOLK SHIRT MANUFACTURING COMPANY. The Norfolk Manufacturing Company made shirts in this building pictured in early 1900 on the intersection of Aurora and Talbot Streets. Subsequently, the Economy Furniture Store and then Whitely's wholesale business located here. Later, a brick office building was constructed on the site.

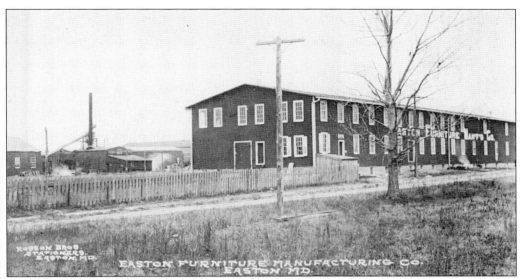

THE EASTON FURNITURE MANUFACTURING CO. The company on east Brooklets Avenue was founded in 1899 and lasted until the 1930s. It was among the largest employers in Easton during the heyday of oak furniture, much desired for dining rooms and bedrooms. William Kemp, son of the secretary/treasurer, William H. Kemp, moved to Goldsboro, North Carolina, in 1930 to continue a successful furniture business there.

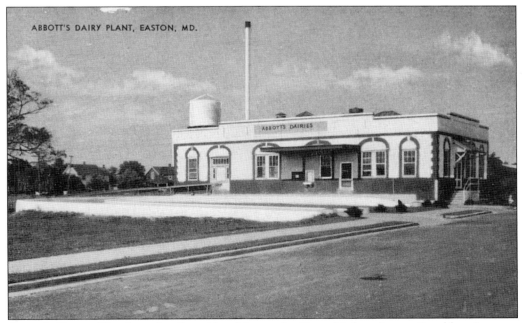

ABBOT'S DAIRY. The dairy distributed local farmers' milk at this location on Brooklets Avenue. It supplied the Philadelphia Company with A1 milk for Abbot's ice cream.

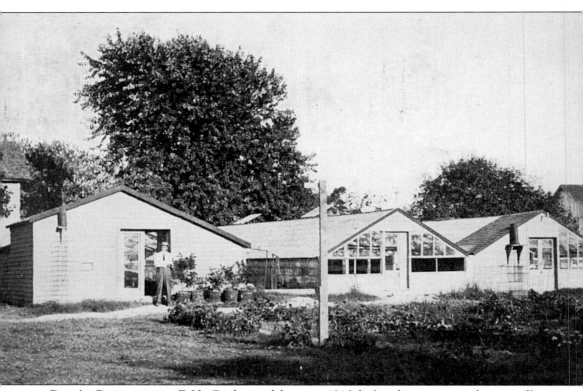

COOK'S GREENHOUSES. D.H. Cook stood here in 1910 before his new greenhouses off east Goldsborough Street. Cook's slogan "Funeral Designs and Cut Flowers a Specialty" helped keep the business operating until the 1950s.

Five

PUBLIC PLACES

The first formal schools in Talbot County were run by the Society of Friends, which, among others, had a school at Betty's Cove Meeting in the 1670s. Third Haven Meeting organized Friends Select School on Bay Street in 1874. The state public schools began in 1865, and it is these buildings that are recorded here. Many private schools operated throughout the years, but they have not appeared on postcards. Friends Select School is pictured on page 73.

Easton's first hospital, pictured on page 25, started under the energies of Mary Bartlett Dixon (Cullen) in a rented building. When this overcrowded building burned, $43,000 was subscribed within six weeks for the construction of the Memorial Hospital. Elizabeth Wright (Dixon) and Mary Bartlett Dixon (Cullen) founded a nursing school in 1907, which is today the MacQueen Gibbs Willis School of Nursing.

Other public buildings included here are the post office, the armory, the water tower, the fire hall, and finally, the cemetery. The cemetery was the site of an epochal event in the town's history when the great Whig meeting of 1840 was held there. For that occasion large trees were dug from the woods and planted around, the cool spring provided water, invitations were extended to the leading Whig orators and statesmen, a sumptuous dinner was held, nine steamboats arrived from Baltimore, and 15 to 20 thousand people gathered to hear the orations long into the night. A Whig landslide swept the elections that year.

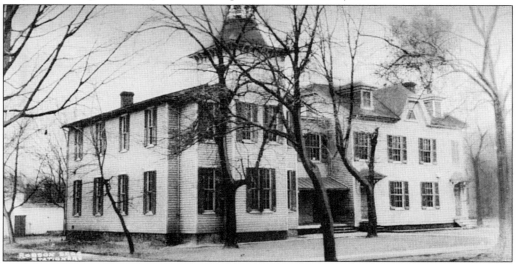

PRIMARY SCHOOL. The two school buildings built in 1835 and 1865 were called first the County School, then the Male School of Easton, and later the Female School of Easton; the buildings were eventually connected. The school closed in 1929 when all students were moved to the high school on Hanson Street. John Williams bought it, much run-down, in the early 1930s for use as an antique shop and funeral home. It is now the Academy of the Arts.

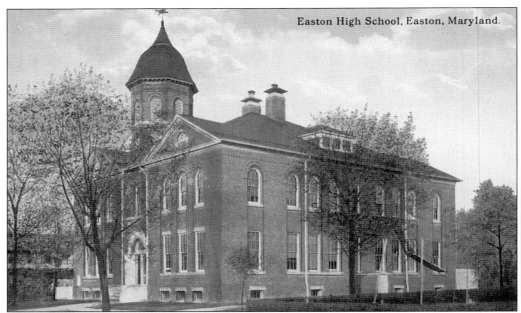

Easton High School, Easton, Maryland.

EASTON HIGH SCHOOL. The old school on south Hanson Street was built in 1820 and was ultimately replaced with this structure in 1894, which in turn was demolished in 1954. The weathervane was a 2-foot quill made of copper.

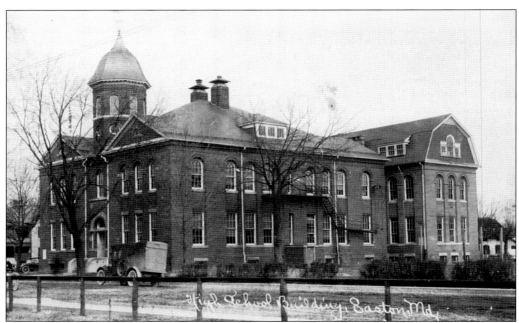

EASTON HIGH SCHOOL. Including the rear addition, the school, at its busiest, held classes on all three floors. Cooking and manual arts were taught in the basement. The first school cafeteria started in the early 1930s, offering a full platter lunch for a quarter. Many children were scolded for sliding down the concrete ramps on either side of the main entrance. The building has been replaced by the county health department.

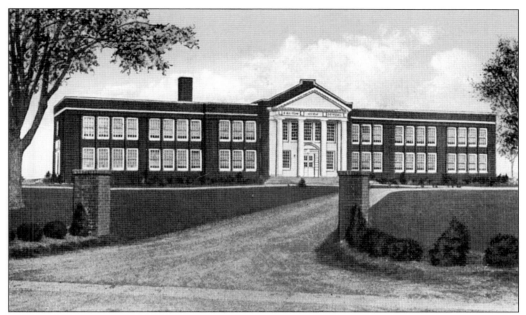

EASTON HIGH SCHOOL, A CAT'S-EYE VIEW. The high school was built in Idlewild Park. Most students preferred the entrance on the left or at back because the principal's office and teachers' lounge flanked the main entrance. The school no longer stands, leaving the park to grass, swings, and a sports field.

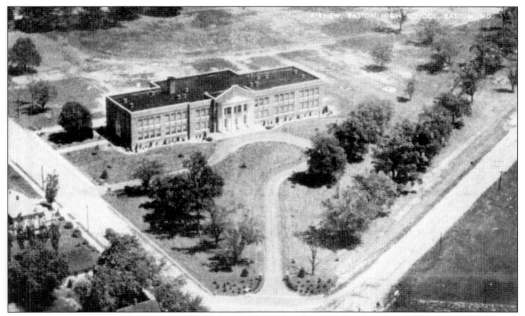

EASTON HIGH SCHOOL, A BIRD'S-EYE VIEW. The school was completed in 1929. The shadow of the old fairground oval, a track for horse and other racing, is at the top of the picture. The early traffic pattern to the school came off the five corners (two of which are visible here), making this entrance into town at the Oxford road juncture a six-corner intersection.

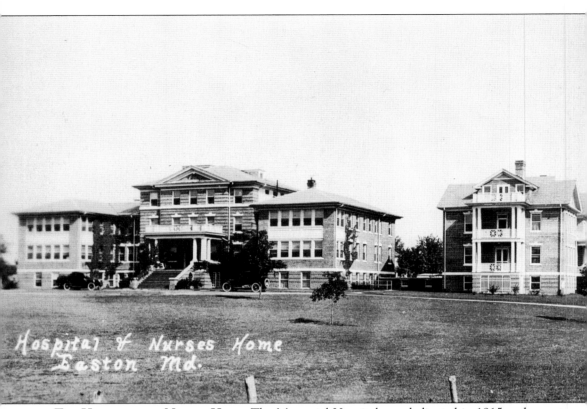

THE HOSPITAL AND NURSES HOME. The Memorial Hospital was dedicated in 1915 and was at once so overcrowded that no nurse ever slept in the 14 beds intended for the nurses' quarters. In 1930, there were 8 doctors, 17 nurses in training, and 5 graduate nurses for about 1,100 patients. This card of 1923 shows the Nurses Home addition, later torn down, at right.

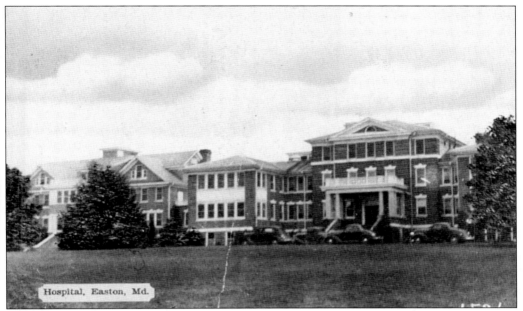

Hospital, Easton, Md.

THE MEMORIAL HOSPITAL. The hospital grew with the addition of the maternity wing in 1929. The funds for this expansion were donated in large part by Milton Campbell.

THE MEMORIAL HOSPITAL. A further, and sizable, expansion of the hospital completed in 1955 brought the bed capacity to 166. Several more additions and changes have swallowed up the old buildings into a complete and modern hospital complex.

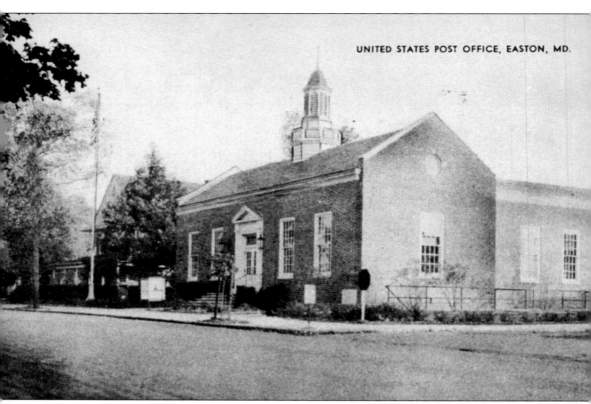

THE POST OFFICE. Constructed in 1936, this building on Dover Street replaced the Washington Street location. After an expansion, the post office also housed the Internal Revenue Service and the Agricultural Extension Service of the University of Maryland. In the 1980s, the adjacent Borden-Smith house was demolished to make parking spaces.

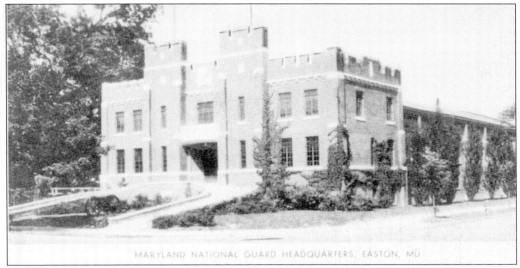

MARYLAND NATIONAL GUARD HEADQUARTERS, EASTON, MD

THE MARYLAND NATIONAL GUARD HEADQUARTERS. Built in 1927, the Armory served the National Guard through World War II. The cannon in the oval is reputed to be from the defense of Fort Stokes in the War of 1812. When the British fleet attempted to get to Easton by the Tred Avon River, the town put up an embankment for five hundred men and pieces of artillery near Easton Point. It was called Fort Stokes for the stalwart old soldier leading them. The British ran aground on Benoni's Point and never arrived. The photograph was taken in the 1930s.

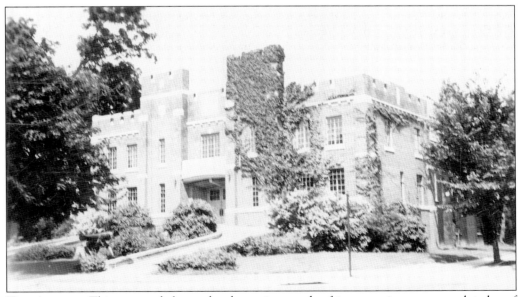

THE ARMORY. This postcard shows the dramatic growth of ivy covering one crenelated roof tower in 1938. The semi-oval entrance was later removed because it proved too slippery when wet, and the cannon was placed at the American Legion Home on Dover Street. The building is now used as the headquarters for the annual Waterfowl Festival.

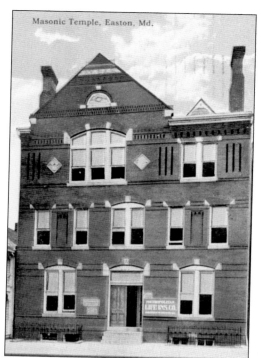

Masonic Temple, Easton, Md.

THE MASONIC TEMPLE. This very private order for a public service, the Order of Masons, probably had a lodge in Easton as early as 1749. They built this 1880 building, pictured in 1923, to be the new home of Coates Lodge number 102. It is situated where an old bake shop and oyster house had once stood on North Washington Street. Masonic symbols are carved in relief under the arch in the gable and on stone shields at the third-floor level where the lodge meetings are held.

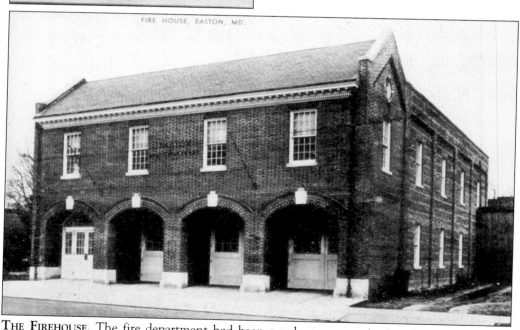

FIRE HOUSE, EASTON, MD.

THE FIREHOUSE. The fire department had been a volunteer organization since its inception in 1879 after the big fire of October 1, 1878. This event caused the town to take such fire-prevention measures as getting a steam engine, an 1,100-foot hose, and large wells sunk on Washington Street (a town ordinance was needed to forbid the washing of clothes in them). The firehouse on Harrison Street was built in 1933. When a larger one was completed in 1962, this building was used by the mayor and town council, as well as the police department.

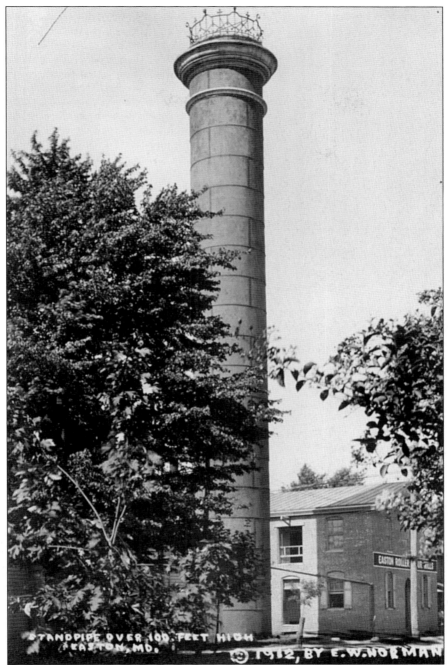

THE STANDPIPE. The water tower on North Hanson Street, constructed in 1886, was designed by Isaac S. Cassin to hold 800,000 gallons, an amount that would increase water pressure for the town. At 100 feet high, made with riveted wrought iron plates and a crown-like top, it is the tallest structure in Easton. Behind is Bartlett's Roller Mill, which produced flour from 1880 through World War II. Later the *Star Democrat* newspaper was printed there. Now One Mill Place is an office building.

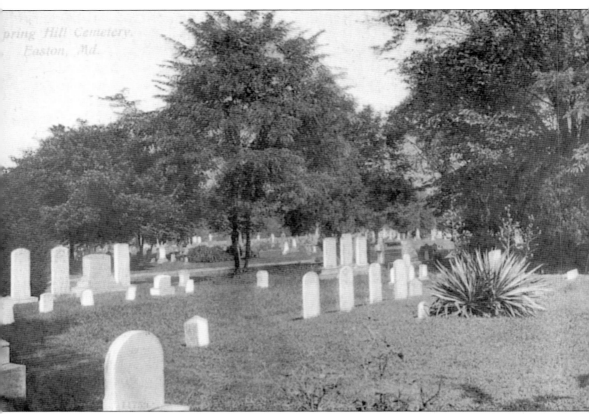

spring Hill Cemetery.
Easton, Md.

Spring Hill Cemetery. Would you caption this card, "Wish you were here?" The Methodists and Episcopalians combined their lots with several acres belonging to Robert Dixon and Col. Sam'l Hambleton, and enclosed this well-kept cemetery in 1877. Before that, citizens subscribed to a "Potters Field" on the same grounds for the use of the "several denominations of Christians, strangers and people of color." It was the site of the great Whig meeting of 1840.

Six

PLACES OF WORSHIP

The oldest structure in Easton, in fact the oldest documented building in Maryland, is the one where members of the Religious Society of Friends worship. Quakers built "ye greate meeting house" in 1684, having come to Maryland very early to find haven from persecution. Friends still meet in the 1684 building, although they have had a newer one since 1879.

As the Quaker Meeting House stood outside the town boundaries, it can be said that the first place for religious worship in the town, of which there is an authentic record, is that of the Methodists. Their first church was built on property on Goldsborough Street deeded in 1790. Methodism had spread into Easton in 1777 after Joseph Hartley was jailed at Talbot Courthouse for refusing to take Maryland's Oath of Allegiance, and preached the gospel through his cell window. Francis Asbury and Freeborn Garrettson often visited, gathering converts. Throughout the years, Methodists of varying persuasions have built at least seven churches—the earliest one, the Asbury and Bethel A.M.E. churches active today, the Ebenezer, Calvary and Trinity Churches closed in the consolidation, and the large United Methodist Church on Peachblossom Road.

The Protestant Episcopal congregations worshipped at a brick church on Harrison Street in 1803, then at the Handsome Gothic revival church on South Street. By 1868, Episcopalians had acquired a second place of worship in Trinity Cathedral.

Catholics also acquired their church on Goldsborough Street just after the Civil War. Of the places of worship of the many other denominations in Easton, there are regrettably few postcards to include.

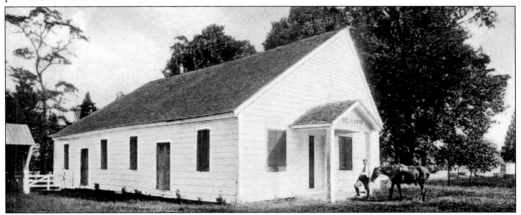

THE FRIENDS OLD MEETING HOUSE. The plain lines and modest size of this wooden building reflect the Quaker testimony on simplicity. Oak beams hewn from the grove surrounding the house are visible in the interior, giving historian and architect a rare look at 17th-century methods of construction. The Roman numerals, 1684, were whitewashed over in the 1940s. The carriage shed can just be seen at left.

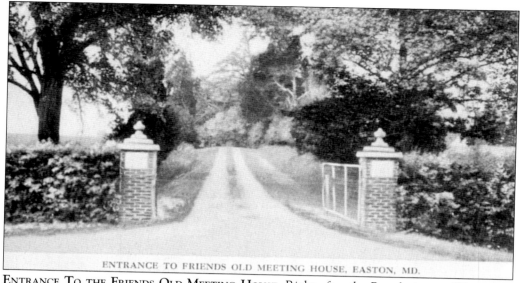

ENTRANCE TO FRIENDS OLD MEETING HOUSE, EASTON, MD.

ENTRANCE TO THE FRIENDS OLD MEETING HOUSE. Right after the Revolutionary War, when Friends stopped coming to Meeting by boats and used the improved roads, the Meeting traded their former river access for this frontage on Washington Street. This view of 1920 shows the site surrounded by fields and the now shaded avenue of pines put in by Robert L. Kemp in 1935, as an open country lane. A sexton's house dating from 1867 is just visible at right.

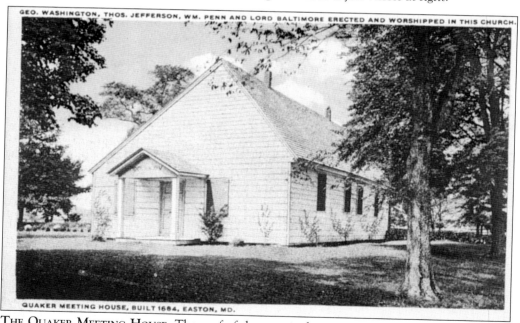

GEO. WASHINGTON, THOS. JEFFERSON, WM. PENN AND LORD BALTIMORE ERECTED AND WORSHIPPED IN THIS CHURCH.

QUAKER MEETING HOUSE, BUILT 1684, EASTON, MD.

THE QUAKER MEETING HOUSE. The roof of the meetinghouse was originally symmetrical, but an enlargement after the Revolution widened the building westward, eliminating two smaller perpendicular wings on each side. This 1930 card shows the carriage shed moved, a historic garret window sealed off, and the building almost flat on the ground. In 1989, the building was lifted 6 feet, completely gutted of decay and rot, and each board authentically replaced. As there is no heat or electricity, worship is held there only in warmer months.

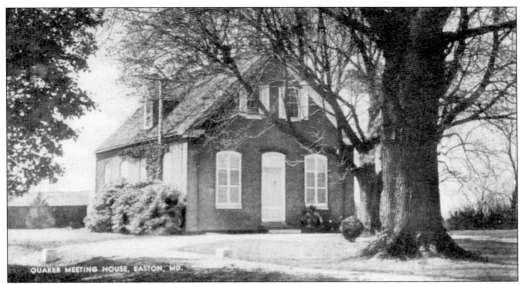

THE QUAKER MEETING HOUSE. The "new" meetinghouse was begun in 1879 when the members felt the old one was too far gone. Robert Dixon paid for one more shingling of the roof, and the ancient building survived. Meeting is held here in the winter. The carriage shed has been moved behind this house. The rhododendron bushes on the south wall have grown to the roof-line and out to the road, but the large maples are gone, as is the last oak of the old grove.

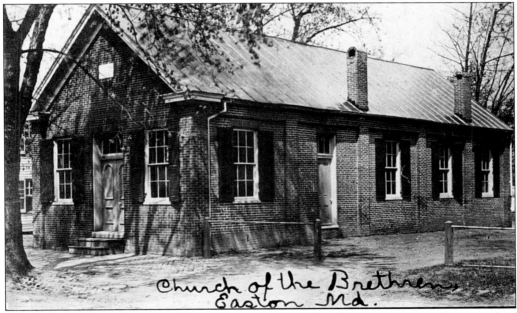

THE CHURCH OF THE BRETHREN. The Brethren first met in Peachblossom Meeting House south of town and then, until 1950, in their own church at this location on 7 Bay Street. The brick building was constructed by Third Haven Friends Meeting in 1874 as a school for all denominations, girls and boys, for primary through college preparation. Wilson M. Tylor, principal, and Emma Satterthwaite oversaw it. The site is now the location of Talbot Cleaners.

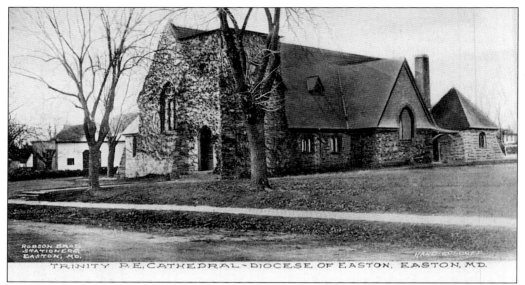

TRINITY CATHEDRAL. Easton became a "see" in 1868 when the Episcopal Diocese of Easton was formed. In 1876, a church was built on two Goldsborough Street lots bought from I.C.W. Powell. Bishop Henry C. Lay advocated a second Episcopal congregation in Easton, primarily for those who sympathized with the Southern cause. The present granite church was consecrated in 1894. The unfinished square tower did not receive a spire for one hundred years.

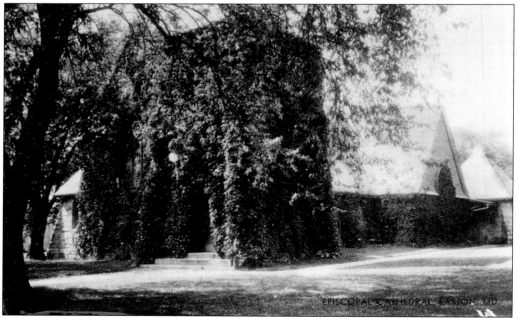

TRINITY CATHEDRAL. The cathedral here is only 35 years old, but the ivy growth and mediaeval architectural style create a feeling of antiquity. Almost obliterated from view are the entrance and tower, which is yet to have its spire put in place. The early Gothic parish church revival movement can be seen in arched windows and stone buttressing.

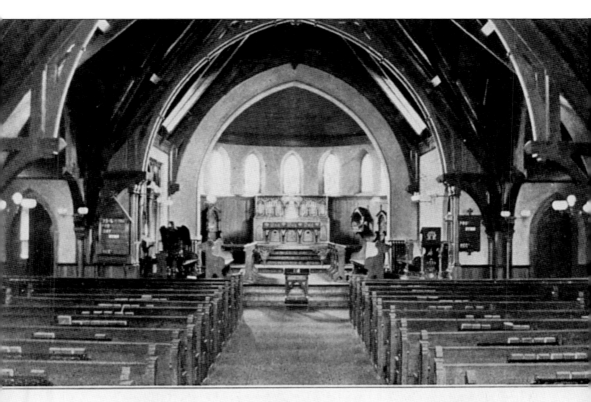

TRINITY CATHEDRAL, EASTON, MD.—INTERIOR

TRINITY CATHEDRAL INTERIOR. This interior view, taken about 1920, shows the beauty of the Gothic style with dramatic vaults and echoing arched windows.

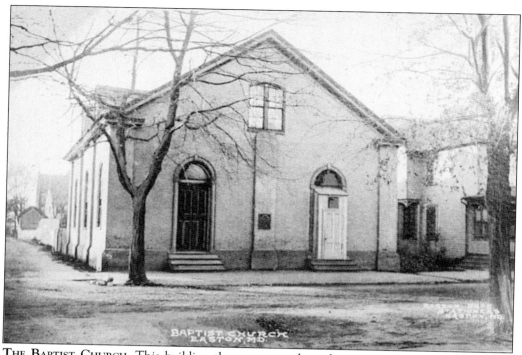

THE BAPTIST CHURCH. This building that once stood on the corner of Harrison Street and Church Alley was built in 1803 as the town's first Episcopal church and was consecrated by the right Reverend Dr. Thomas J. Claggett, the first Episcopal bishop to be ordained in America. It was sold to the Baptists, who built the adjoining parsonage. Fire razed the building in 1952; the site is now a parking lot.

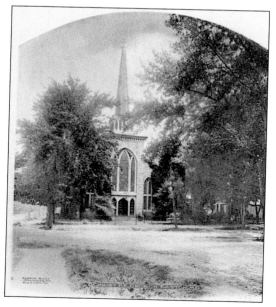

CHRIST CHURCH. This early card shows the new church designed by architect William Strickland and built by the Episcopalians in 1840 when they had outgrown the old brick church. The imposing new Gothic style church was said to be "a jewel in the crown of the church . . ." The spire has had some remodeling from the original one and was the first spire with a bell tower for the town. Grass encroached upon Harrison Street.

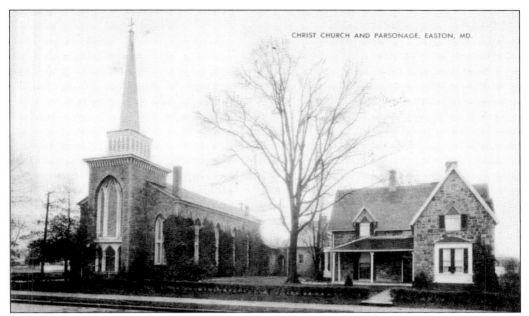

CHRIST CHURCH AND PARSONAGE. The church here reveals the glory of its Gothic-Revival architecture. When an addition to the parish hall was built, granite from the Ebenezer Methodist Church, at the time being remodeled into offices, was acquired. The granite rectory of 1852 was designed by Richard Upjohn, who also designed Holy Trinity Church in Oxford, Maryland.

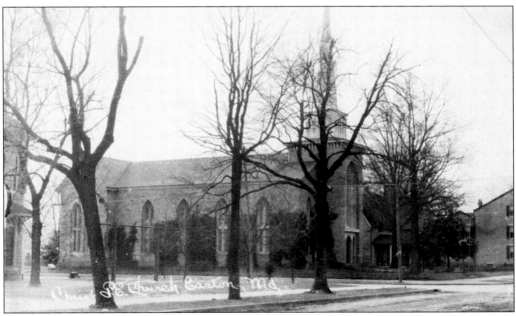

CHRIST CHURCH. This photo postcard of 1922 shows creeping ivy, the weight of which would cause great squares to periodically fall down and blanket the ground, and parts of Harrison Street, only to be pruned and grow back against the wall again.

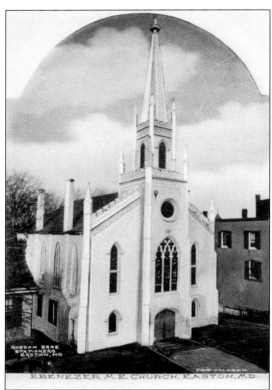

EBENEZER M.E. CHURCH, EASTON, M.D.

EBENEZER METHODIST CHURCH. The church on south Washington Street that was completed in 1856, partially from the bricks of a two-story earlier one on West Street, grew to be the center of Methodism in town for a century and a half. The stucco facade was replaced by granite about 1910 (the granite that later became part of Christ Church parish hall). The congregation here was the largest of all the Methodist churches in town. In 1960, it became the Economy Furniture Store and then was acquired by the Historical Society and Faw, Casson, & Company for use as an auditorium on the second floor, and offices on the street floor.

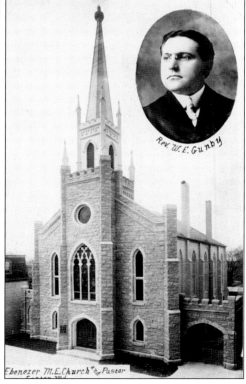

Rev. W.E. Gunby

Ebenezer M.E. Church & Pastor

EBENEZER M.E. CHURCH. The church in this year had a granite facade and flanking crenelated walls. The Travers House at left has gone to be replaced by yet another parking lot. The Reverend W.E. Gunby was the minister in 1915. (Collection of Michael Luby.)

78

CALVARY METHODIST CHURCH. The second largest Methodist church in Easton was on North Washington Street. That branch of Methodism formed in Easton in 1828 and first worshipped at the "old bank" building at the rear of the property. In 1842, this spot was the scene of Easton's largest revival meeting. The church shown here was erected in 1854 and abandoned at the consolidation. It served as the first headquarters of the Talbot County YMCA.

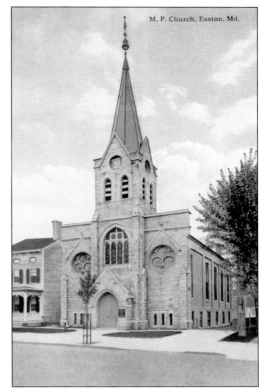

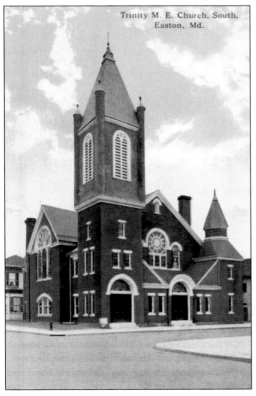

TRINITY M.E. CHURCH, SOUTH. Built in 1875-76, the church was formed after the Civil War for those members who sympathized with the Confederacy. It stood on the northeast corner of Harrison and Goldsborough Streets. The building was razed to become the site of a filling station and then a bank branch office.

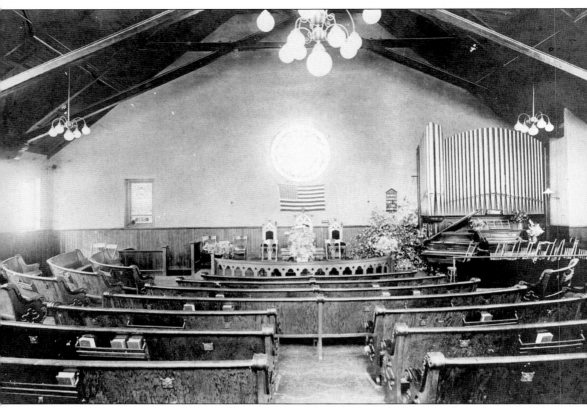

Trinity Methodist Church. This is a rare photo postcard showing the interior of the church. Early congregation sentiments notwithstanding, the flag above the altar was not a Confederate banner.

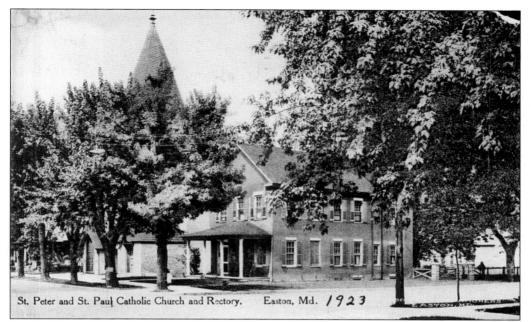

St. Peter and St. Paul Catholic Church and Rectory. Easton, Md. *1923*

ST. PETER AND ST. PAUL CATHOLIC CHURCH AND RECTORY. Early Maryland laws persecuted Catholics and forbade the building of their churches until the Revolution had restored religious freedom to the colonies. Early Roman Catholics in Easton held worship in their homes, which were often built with wide halls to accommodate a crowd, or in Old St. Joseph's Church in Cordova, which the Jesuit Father Joseph Mosley called his home in order to hold Mass. Easton's church was dedicated in 1868.

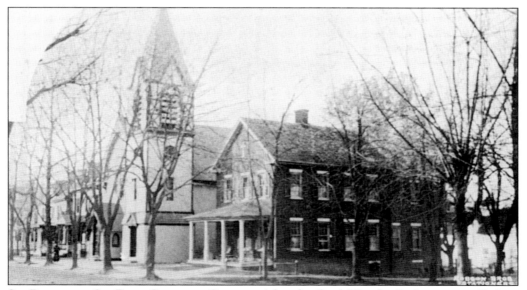

ST. PETER AND ST. PAUL CATHOLIC CHURCH. After the Civil War the Redemptionist Fathers in Annapolis began coming across the Chesapeake Bay by boat to conduct services. Their efforts organized the parish and built the church. The rectory has been slightly enlarged with the addition of a two-story protruding bay on the east wall.

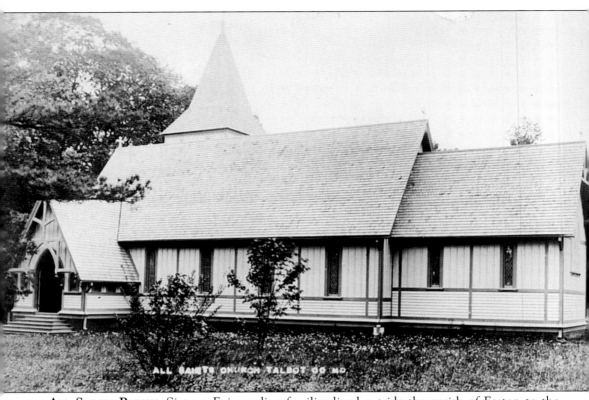

ALL SAINTS PARISH. Sixteen Episcopalian families lived outside the parish of Easton to the north and west and worshipped at this simple frame church on old Centreville road. It has been sold and refurbished as a private residence.

Seven

EVENTS AND PASTIMES

The most eagerly awaited event of the year between 1885 and 1924 was the Talbot County Fair at Idlewild Park. Its promoters spent $500 to extend Harrison Street through Earle's Addition, so that people could more easily come to the fair—and come they did. Attendance was as many as four thousand a day for each of the four days the fair was held.

Of Easton's five major fires the first four occurred along Washington Street. After large sections of the courthouse square had burned three times, the town modernized its equipment and purchased the "Little Giant" steam engine for $1,500. Before that, as the town's two horses were needed to pull the garbage wagons, 12 firemen hauled their engine to the fire.

Railroads arrived after the Civil War, and in 1870, Easton at last had a depot. Trains left for connection to New York, taking fruit and passengers. A few years later a line ran in from Claiborne on the Chesapeake Bay, connecting the steamboat from Baltimore to Ocean City. Eventually, the Pennsylvania Railroad bought out the lines and sent passengers up to Wilmington, Delaware, on the *Bullet*, which stopped at every small town along the way.

The game of baseball came to town in 1867. A newspaper reported on September 6 that the Trappe Choptanks defeated the Easton Fair Plays in seven innings, 85-47, at Easton's home field on Point Road. Two postcards show the Easton ball teams of the Class D professional league; unfortunately none show the ballpark at Federal Field.

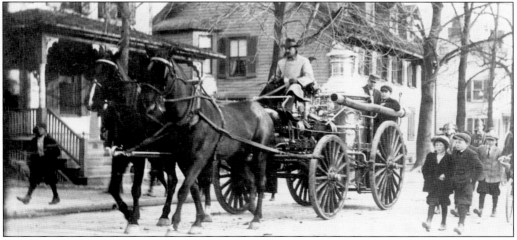

THE FIRE ENGINE. Here is Easton's famous radial pumper bought from Carlisle, Pennsylvania, in 1915 for $1,000. Easton used the horse-drawn vehicle in a motorized age for almost 30 years, the last time being for the Avon Hotel fire in 1944. The street view looks south on Washington Street opposite the Historical Society. The houses were destroyed to build the Chesapeake and Potomac Telephone Company. Local firemen walk behind the pumper; the three boys are a Frampton, Frank Oman, and Walter Garey.

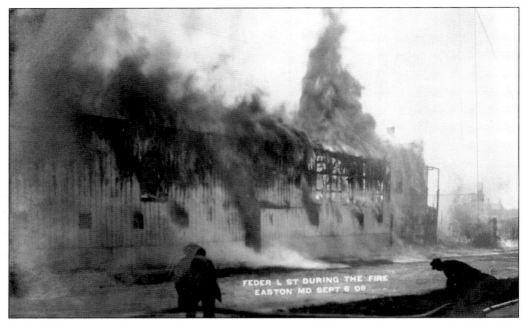

FEDERAL STREET DURING THE FIRE. Fires were major and frequent disasters in the life of the town. Easton suffered losses of entire blocks in the fires of: February 28, 1808; March 13, 1813; March 25, 1813; March 25, 1855; October 1, 1878; and August 11, 1954. The photographer was lucky to be on hand for the conflagration on Federal Street of September 6, 1909. The firemen are pulling on the fire hose.

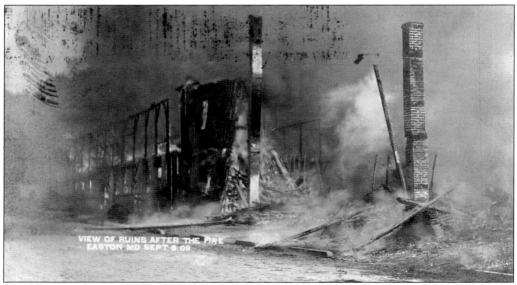

VIEW OF THE RUINS AFTER THE FIRE. Smoking ruins remain on Federal Street just after the September 6 blaze. The buildings were replaced by Lon Nichols's stockyard.

We invite you to see exhibit at the

Talbot County Fa

Easton, Md., Sept. 17. 18, and 20. A full line of

Reeves Engines and Thre ers, Stevens Engines a Threshers, Wood Bro's. St Self Feeders, Safety Corn Husk Joliet Corn Shellers, American S Mills, Corn King Manure Spread Ontario Grain Drill and a large displ of Machinery and Implements. Make our pl your headquarters while you are in town and the grounds. Your friends,

Shannahan & Wrightson Hardware Compan

TALBOT COUNTY FAIR. This was an advertising postcard for the hardware company. The fair was held between the years 1885 and 1924. Along with the farm machinery advertised here, there were displays of home preserves, handwork, and prize animals.

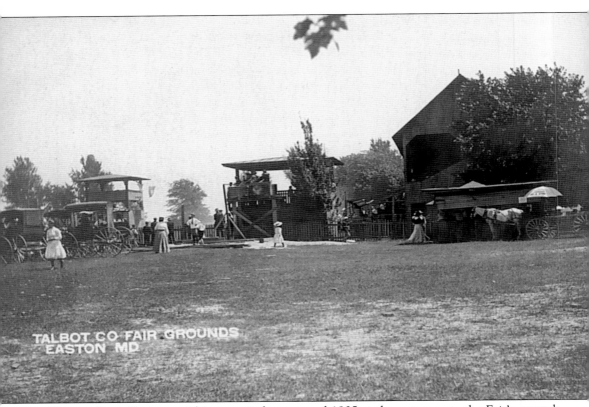

TALBOT FAIR GROUNDS. This scene is from around 1905 at the entrance to the Fair's grounds where Idlewild Avenue is now. The exhibition building was to the right along Washington Street, while the racetrack and grandstand were behind the judges' stand to the left.

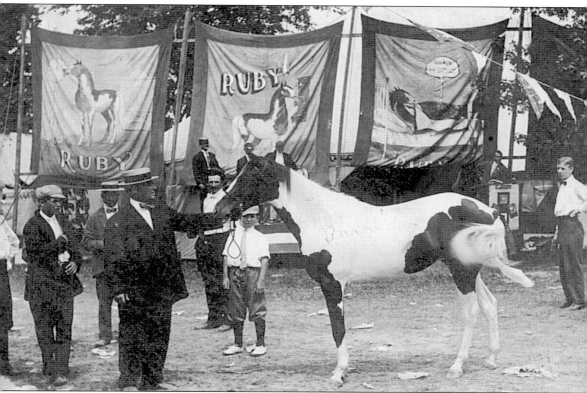

TALBOT COUNTY FAIR. Among the exhibits one year was Ruby, the trick horse. The banners depict some of her tricks. In the third one she is pulling the covers up and saying, "good night." Changing the position of her patches from those on the poster may have been her best trick.

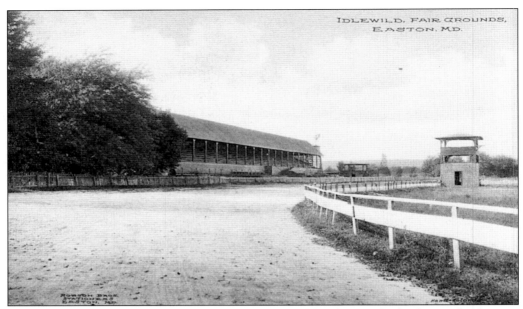

IDLEWILD FAIR GROUNDS. Rounding the first turn and heading to the back stretch, the race began when the people arrived; the grandstands were always filled to capacity by the time the races started. The judges' stand was at right. This picture of 1910 shows a mild degeneration in the fairgrounds.

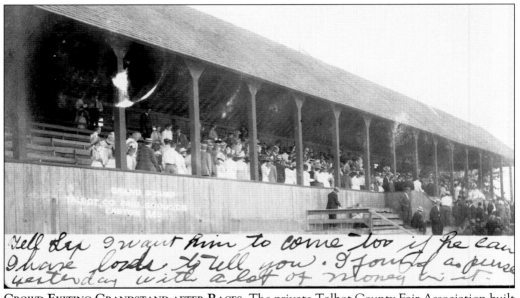

CROWD EXITING GRANDSTAND AFTER RACES. The private Talbot County Fair Association built this, the racetrack, and other buildings for $30,000 after the fair was moved from the hole-in-the-wall (near Trappe) to this site where two railroads intersected. After the races, the crowd would disperse to see hot-air balloons and airplanes in aerial demonstrations.

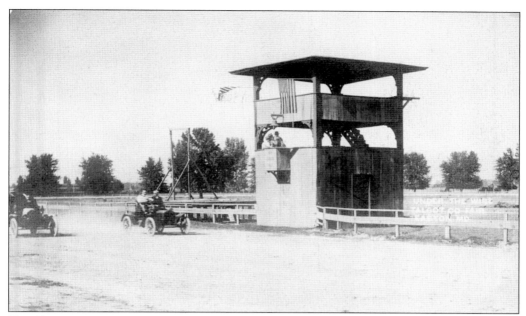

THE FAIR'S GROUNDS, 1909. Coming in under the wire, the hottest race in town was with those new-fangled autos. The judges were giving the finish a close scrutiny.

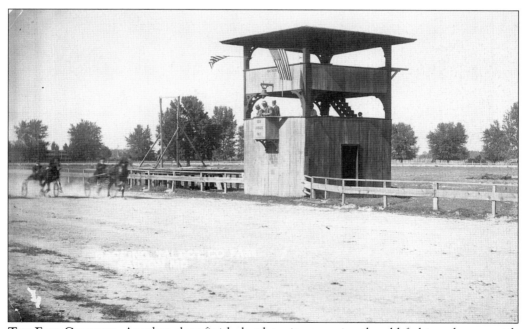

THE FAIR GROUNDS. Another close finish, but here it was racing the old-fashioned way—with horse and sulky. The photograph and the one above could have been taken on the same day in 1909, as races of various sorts were held each of the four days of the fair.

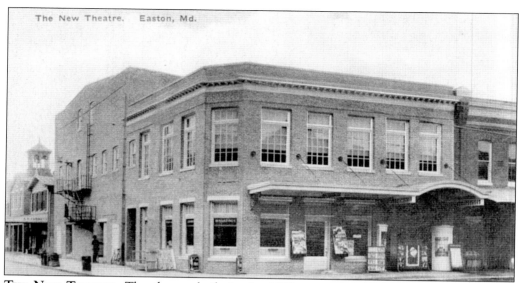

The New Theatre. Easton, Md.

THE NEW THEATRE. The theater built in the 1920s was interchangeably called The New Theatre and the Avalon, for years. In the golden age of movies, the Avalon was the place for young and old alike to go for a newsreel, a special, the comics, and finally the feature film. African Americans were admitted to the balcony only. The loges were removed in the art deco remodeling of the 1930s, but are now replaced, and the nouveau artwork brightened with repainting.

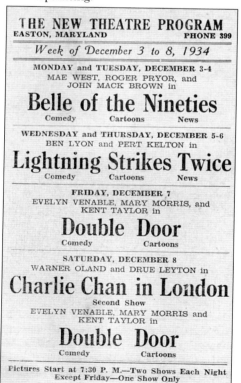

THE NEW THEATRE PROGRAM
EASTON, MARYLAND PHONE 399

Week of December 3 to 8, 1934

MONDAY and TUESDAY, DECEMBER 3-4
MAE WEST, ROGER PRYOR, and
JOHN MACK BROWN in

Belle of the Nineties
Comedy Cartoons News

WEDNESDAY and THURSDAY, DECEMBER 5-6
BEN LYON and PERT KELTON in

Lightning Strikes Twice
Comedy Cartoons News

FRIDAY, DECEMBER 7
EVELYN VENABLE, MARY MORRIS, and
KENT TAYLOR in

Double Door
Comedy Cartoons

SATURDAY, DECEMBER 8
WARNER OLAND and DRUE LEYTON in

Charlie Chan in London
Second Show
EVELYN VENABLE, MARY MORRIS and
KENT TAYLOR in

Double Door
Comedy Cartoons

Pictures Start at 7:30 P. M.—Two Shows Each Night
Except Friday—One Show Only

THE NEW THEATRE PROGRAM. Cards such as this were sent each week to the regular patrons. For 25¢ on Saturday, one could get a double feature, a comedy, and cartoons—not a bad deal, particularly if you met your girlfriend inside.

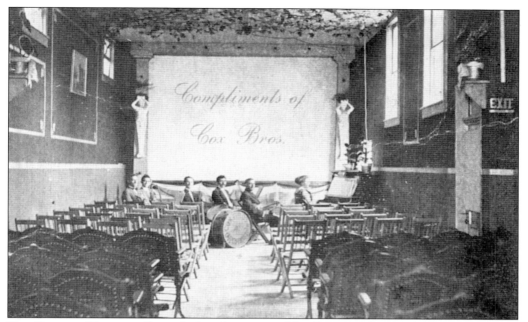

THE PASTIME THEATER. Easton's first theater was The Pastime Theater, located across from the Talbot Bank on Dover Street. It featured live music to accompany silent films of the day. Admission was 5¢. Pictured here is the Cox Bros. orchestra, whose members are (left to right): Herb Cox, Bob Cox, Will Hull, Joe Cox, Bernard Guthrie, and Mrs. Elwood Fields (Clara Cox). The building later became Jump's bowling alley and then a poolroom.

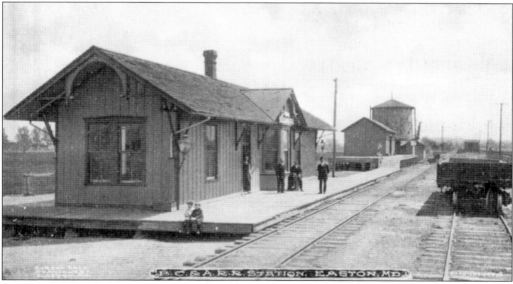

THE BC&A RR STATION. In 1890, General Joseph B. Seth brought the Baltimore, Chesapeake and Atlantic line in from Claiborne. Some local residents never missed meeting the freight, as a stash of freshly made moonshine was often on board. It was notoriously brewed in the still on Poplar Island. Demolition of the BC&A station coincided with the repeal of prohibition. The picture was taken in 1895.

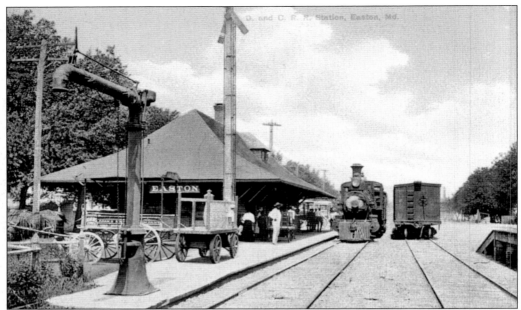

D & C RR Station. The new station for the Maryland and Delaware lines, Delaware and Chesapeake branch, was located 50 yards south of the first station, and is preserved in that spot today. The busy scene of 1910 shows the train's arrival from Clayton, Delaware. The Adams Express horse and wagon waits in the foreground, south of the station, while the passenger buses to uptown are parked northward.

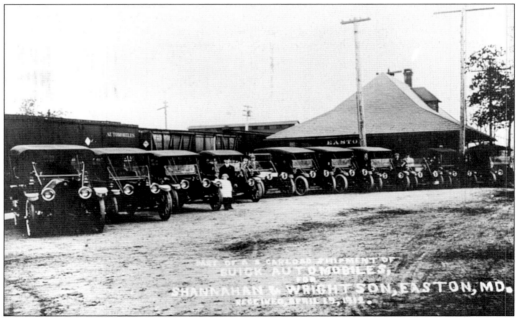

Shipment of Buick Cars. Freight of all description arrived at the Pennsylvania Station. Shown here is the arrival of 12 Buick autos, part of five freight cars worth of shipments going to the Shannahan and Wrightson Hardware Company. The date is April 19, 1912.

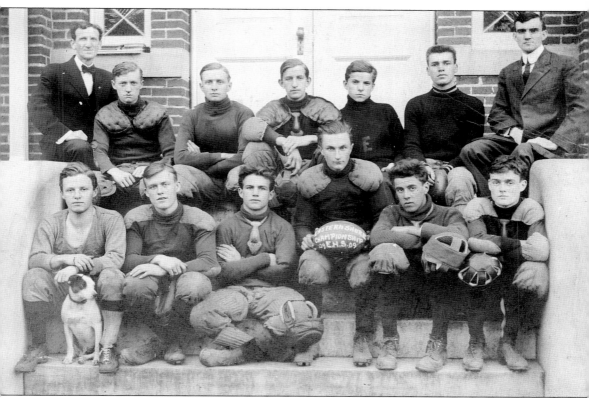

EASTON HIGH FOOTBALL TEAM. The Eastern Shore championship football team of 1909 posed on the steps of the Hanson Street High School. Uncle Billy Hull, a longtime teacher, is at the upper left. Notice how smooth the concrete ramps have been worn.

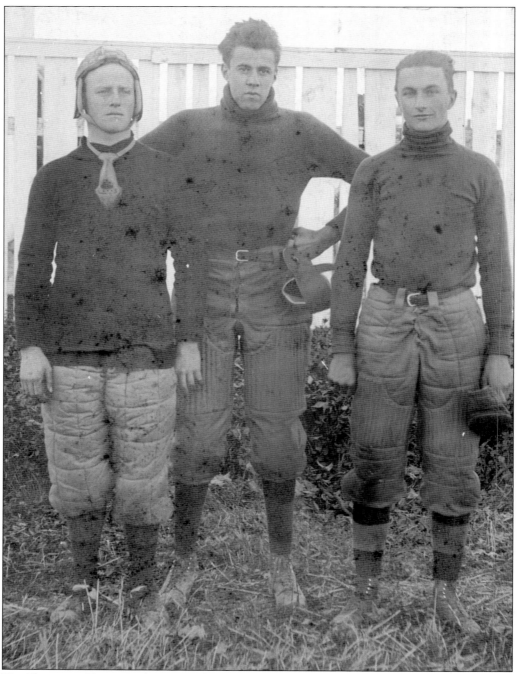

THE FOOTBALL TEAM. A close-up of the three stars from the championship team reveal playing gear that would not meet today's standards nor survive today's play; although it appears that turtlenecks were popular 90 years ago. Ward Cowgill is the player in the center.

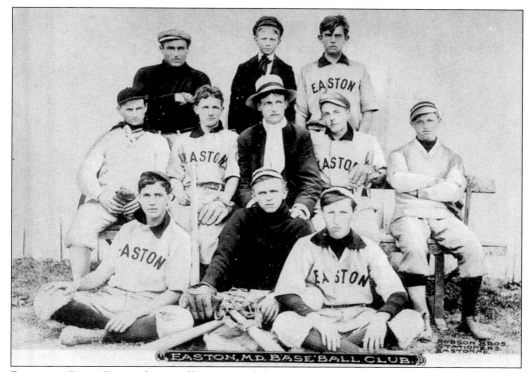

BASEBALL CLUB. Easton fans avidly supported their team on the Eastern Shore League, a semi-pro league that played the Shore during the first half of the century. Easton's ballpark was located at Federal Park, the site of the present St. Mark's Village. These 1905 players were from Baltimore and lived at local boardinghouses, adding a lot of color to downtown Easton. If that is the ball boy at top center, the club must have had to play every game without substitutes.

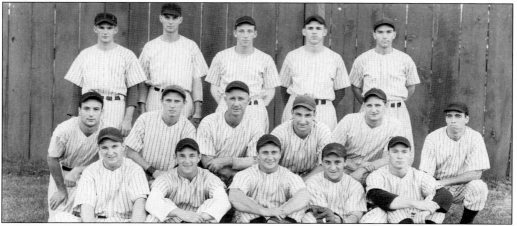

THE BASEBALL TEAM. "The day the (Easton) Yankees won the pennant" of the Eastern Shore League in 1941 is commemorated by this picture of the team. In crisp uniforms, the players of the pro Class D Yankees are: (kneeling) Freddy Ippolito (f), Charlie Zieber (c), Dallas Warren (manager), Dan Smith (p), and "Whirlaway" Ekdahl; (seated) Al Clark, Charlie Hoag (p), Billy DeNof, Al Christiano (3b), and Lefty Merriweather (p); (standing) Joe Murray, Ted Annis, Bill Waupp, Oliver Holmes, and John Greenwal (1b).

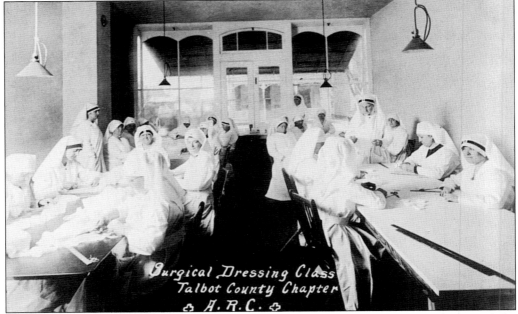

SURGICAL DRESSING CLASS. Volunteers were taught by the Talbot County Chapter of the American Red Cross to make surgical dressings during World War I. Identified women are Louise Adams, facing left, and Helen Coble, on the far right.

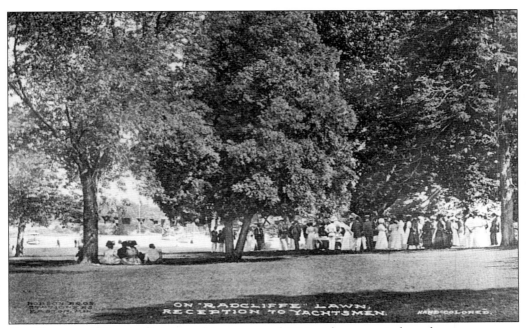

ON "RADCLIFFE" LAWN. This formal lawn party of 1911 with women in long dresses, pennants hanging from trees, and yachts anchored in the river, was held at Radcliffe Manor, just outside the town. It could be the reception following the annual regatta of the downtown Chesapeake Bay Yacht Club.

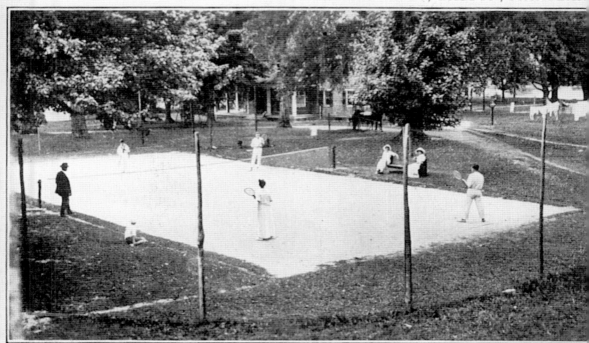

TENNIS COURT

HAI-WA-NOH CAMP. A summer camp was run by the Miller family at their home, The Pines. The women's long skirts probably slowed the pace of this tennis game considerably.

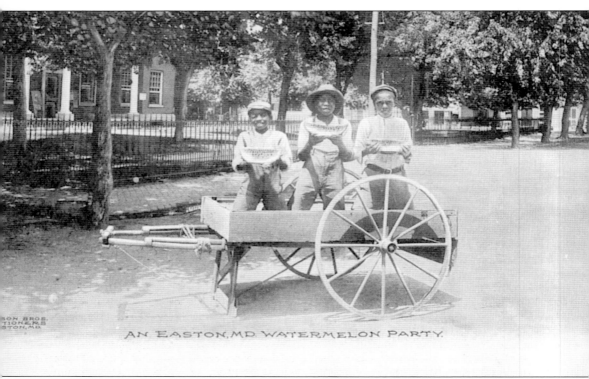

AN EASTON, MD. WATERMELON PARTY.

AN EASTON WATERMELON PARTY. This little group was posed for this postcard, which seemed to have been a favorite for visitors to send back home, representing a stereotypical image of a small Southern country town. The courthouse green behind the boys is lined with a double row of shady trees.

Eight

HOMES

Only a few of the many courtly homes of Easton are depicted in postcards. The homeowner was obliged to subscribe to buying a certain number of cards from the publisher; thus many did not expend the money. Professional photographers of the day were inclined to take the more lucrative street scenes of many homes, and family portraits, rather than pursue the limited market of single home photography.

The cards that are available trace the progress of the town's growth. From the earliest apartments over the city row-house shops and the few large freestanding brick Federal town houses of the town's first years, to the development of residential additions, the town gradually gained in size and population. A history of 1881 gives these names of men who occupied homes of note: Dr. I.L. Adkins, Col. Sam'l Hambleton, I.C.W. Powell Esq., Dr. J.E.M. Chamberlaine, Dr. J.M.H. Bateman, and John W. Cheezum. At the turn of the century, another spurt of growth gave rise to the existence of exuberant late Victorian homes, many of which are commemorated on the postcards included here. The range of architecture reflects the trends from the early Federal style through later neo-Gothic, Greek Revival, Second Empire, and Queen Anne style buildings with all their eclectic variety of Victorian facades.

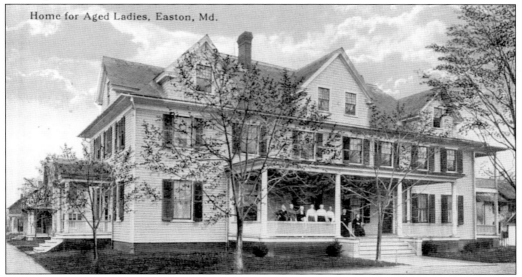

Home for Aged Ladies, Easton, Md.

A HOME FOR AGED LADIES. More colloquially known as the Old Ladies Home, it has been at 108 North Higgins Street for 85 years. Recently converted into apartments and named the Dixon House, after founder and patron, the Quaker Amanda Amos Dixon, it still offers the elderly an affordable home.

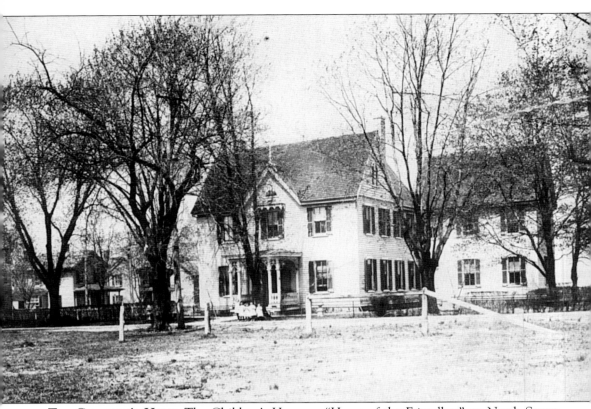

THE CHILDREN'S HOME. The Children's Home or "Home of the Friendless" on North Street housed orphans for nearly a century. A small cluster of children can be seen grouped at the front porch. Today the home is in apartments, and the Children's Home Foundation offers educational scholarships to local youth.

THE MILLER'S HOUSE. The very old little story-and-half wing of this house on North Hanson Street, joined to a 19th-century two-story structure, has rare wide-beaded siding under the shingles. It was probably used by the miller of Bartlett's Mill, located next door. Joseph Councell, a carpenter, built the larger addition. The drawing is by Edna S. Hammond.

THE KENNARD-DAWSON HOME (DAWSON-LEONARD HOUSE). The narrow, Federal period house, with its long lawn stretching to Washington Street, stood at the Bay Street intersection, and was perhaps the home of John Kennard, who in 1810 sold his lot to the Farmers Bank (NationsBank) and moved his house. Before it was torn down to make way for the Safeway supermarket, it was a realtor's office and an antique shop operated by Nesta Weir and Anna H. Buck.

101

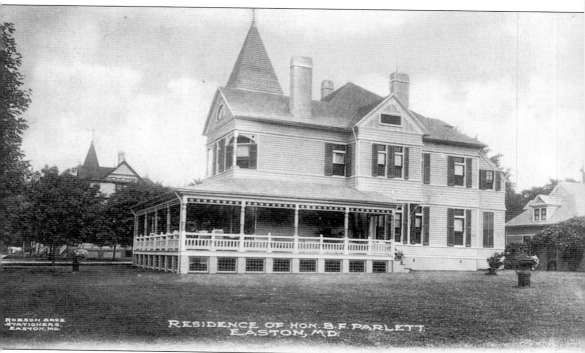

RESIDENCE OF HON. B.F. PARLETT.
EASTON, MD.

THE RESIDENCE OF HON. B.F. PARLETT. Built in 1890 by a wealthy Easton merchant, Benjamin F. Parlett, and designed by Baltimore architect T. Buckler Chequier, the exorbitant Victorian home on the corner of Harrison Street and Brooklets Avenue is graced with a pyramidal tower, balconies, and extensive porch. It stands on a corner of fine Victorian buildings where the roof-lines of one, the Chaffinch house, can be seen in the distance. The Parlett house was for many years the home of Arthur Grace, and then of Maurice Newnam Jr., who runs a funeral establishment there. Two cannonballs were embedded on the street side of the sidewalk, and they were greased heavily at Halloween to keep the local boys from digging them out and rolling them down the street. They are there today. Behind the home on the right stood an elegant horse stable.

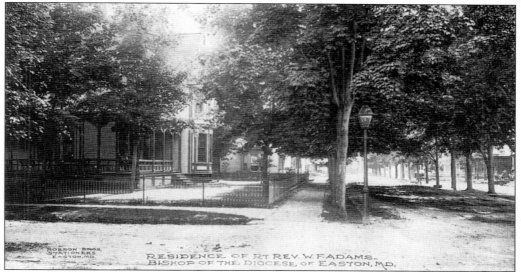

The Residence of Rt. Rev. W.F. Adams. The house shaded by trees was built by Philip Francis Thomas after his retirement around 1880. He was a former governor of Maryland and secretary of the treasury under President Buchanan. His widow sold the house to the diocese of Easton for the bishop's home, and now it is in private hands as a bed and breakfast. The line of trees ran west from Goldsborough Street up to Washington Street.

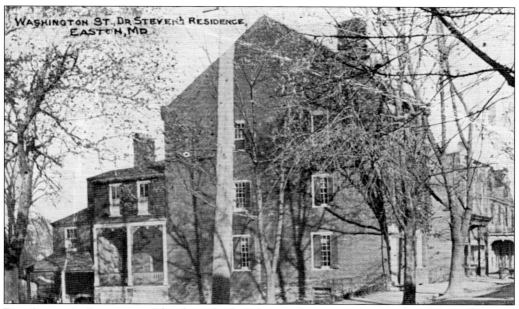

Dr. Steven's Residence. This large high-style townhouse is an example of Federal period architecture at its finest. Built about 1810 by Quaker cabinetmaker James Neall and his wife Rachel Cox Neall, it was carefully designed and constructed. Dr. James A. Stevens bought the house in 1907, and he and his son Dr. Alexander Stevens were the last to live and practice medicine there. In 1956, the Historical Society of Talbot County has been restored and furnished as a substantial 19th-century Quaker family's home.

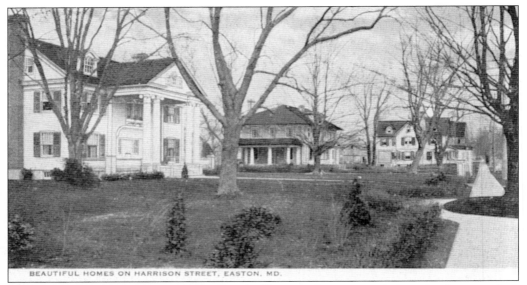

BEAUTIFUL HOMES ON HARRISON STREET, EASTON, MD.

BEAUTIFUL HOMES ON HARRISON STREET. As Harrison Street extended south, these spacious homes with large lawns were erected. Judge William Mason Shehan's house is the columned one with a Greek Revival influenced portico. Alongside is the residence of state senator Harry Covington. A new sidewalk was detoured to save the large tree.

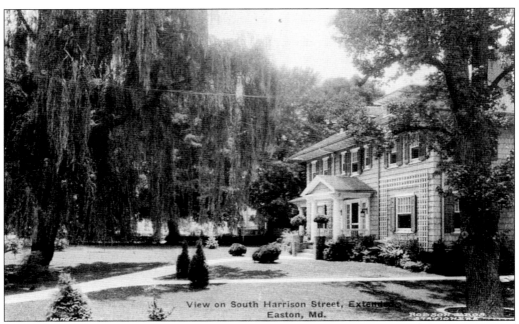

View on South Harrison Street, Extended, Easton, Md.

VIEW OF SOUTH HARRISON STREET, EXTENDED. The Covington home and lawn is featured in this picture taken before 1920. Lon Nichols, a mule dealer, later owned the house. On the lawn stood a life-size cigar store Indian, which proved an irresistible Halloween temptation for neighborhood boys.

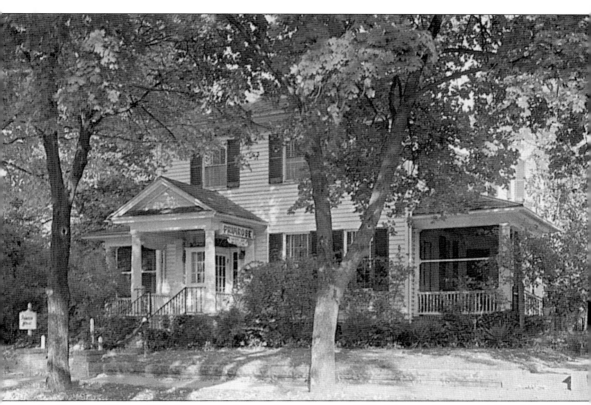

AN EASTON HOME. This house, at the northeast corner of Washington Street and Brooklets Avenue, is pictured as it was in 1912, although today the homes along the block appear much the same as they did then.

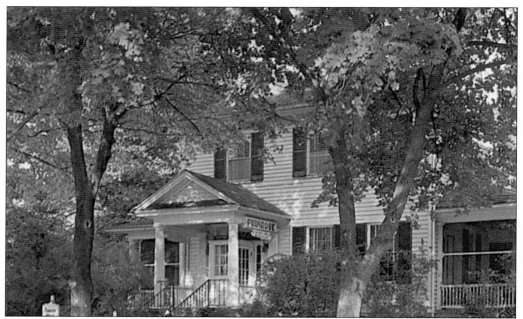

THE PRIMROSE HOUSE. The house at 20 North Aurora Street not only took in tourists, but also leased apartments.

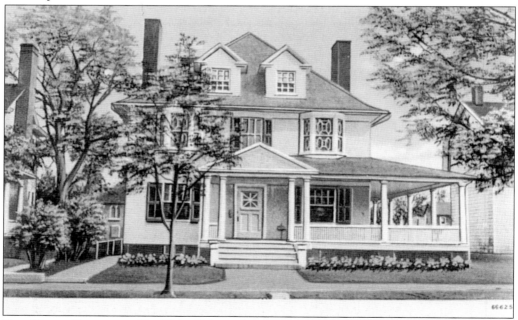

THE TOBIN RESIDENCE. Dr. T.A. Tobin, chiropractor, had a home and office at 18 North Aurora Street. When the home was built at the turn of the century for Edward B. Hardcastle, it was one of the largest on 'silk stocking row' and represented the newest style of architecture. The square-hipped roof sweeping to the eaves, symmetrical window patterns, elegant glasses, and the pediment over the entrance, designed with inlaid cobblestones, all contribute to its prominence. A large carriage house at the rear had an elaborate cupola.

Nine

ON THE OUTSKIRTS

It is said, "all roads lead to Rome," and since Easton is at the center of Talbot County, roads from all directions eventually arrive at the town. The clearing of roads from outlying farms, where the region's early wealth was produced, was necessary for the town's growth. The advent of automobiles made the upgrading of dirt roads into macadam surfaces imperative.

Because estuaries from the Chesapeake Bay thread their way deep into the countryside, creating numerous points and necks of land, bridges are essential to the roads. The construction of a railway line to Easton was delayed at times by the need to first complete a bridge. Early landmarks were identified often by the bridge, as in Pitt's Bridge, or a landing, as in Cowe Landing. The postcards herein give a glimpse into the surroundings to which the roads and bridges opened the way.

These cards depict the rural setting of the homes and manorial lands of people who played a role in the history of both town and nation. Talbot County is uniquely graced with more than 600 miles of waterfront, luring early settlers to establish homes where there were fertile fields for planting and deep water for boats. Many estates have survived to the present, and people who have the means, still find the lure of land and water pull them to this land of pleasant living.

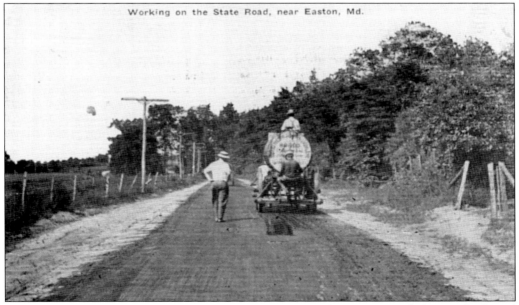

Working on the State Road, near Easton, Md.

WORKING ON THE STATE ROAD, NEAR EASTON. State highways were still dirt roadbeds and were improved by regular oiling when this 1920 scene was captured. The foreman does not seem to be particularly challenged by the rigors of his job, or concerned with the fate of his shoes.

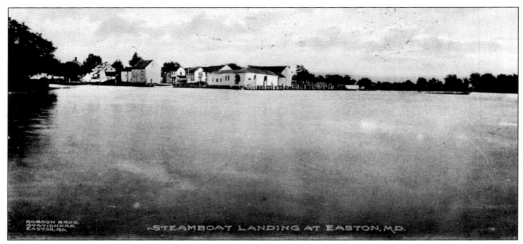

STEAMBOAT LANDING AT EASTON, MARYLAND. The coming of steamboats to Cowe's Landing (Easton Point) began in 1816, bringing a century of commerce and excitement to the area. After the Civil War, luxury passenger steamers could accommodate four hundred passengers. Overnight runs from Baltimore included stops at Easton, Double Mills, Goldsborough's Wharf, Oxford, Clora's Point, Jamaica Point, and Secretary Creek. The age of steamboat travel was over in 1932 when the last stop at the Easton landing was made.

LONDONDERRY. The house, intense with Gothic features, was built in 1860 and designed by Richard Upjohn, who also planned the Christ Church rectory. Its location on Port Street (Point Road) was part of Francis Armstrong's 500-acre grant, Londonderry, on which the Talbot Courthouse was built. Papermill Pond is in the foreground; and at the top of the card, the railroad trestle, as it crosses the Tred Avon, can be seen.

108

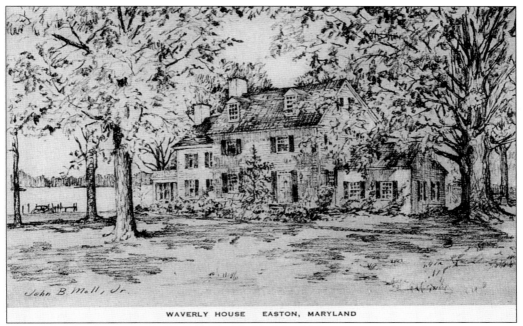

WAVERLY HOUSE EASTON, MARYLAND

WAVERLY. This house was built in the first half of the 19th century on land that was once part of John Edmondson's vast holdings. In 1910, Dr. J.M.H. Bateman bought the 333-acre farm on the Tred Avon River for $13,000.

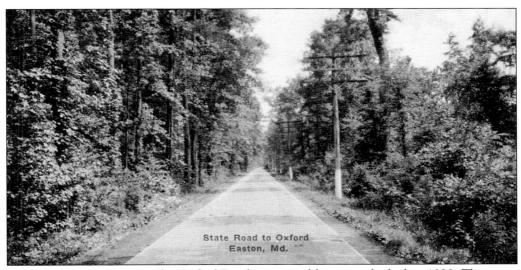

State Road to Oxford
Easton, Md.

STATE ROAD TO OXFORD. The Oxford Road is pictured here as it looked in 1920. The scene looks north from Cooke's Hope to Waverly, at a time when there were woods on both sides. The shoulders were seldom up to grade, which made passing interesting.

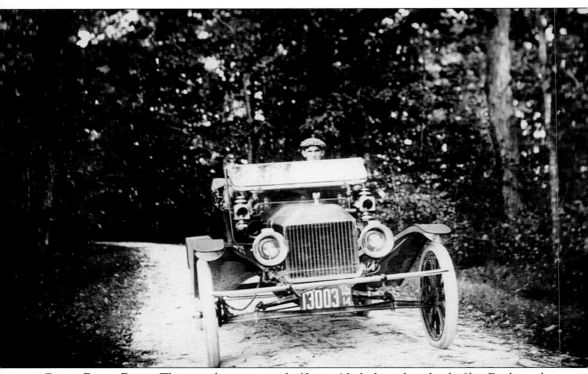

CEDAR POINT ROAD. This is a photo postcard of Lacey Nichols at the wheel of his Ford, on the Cedar Point Road, a mile south of Easton. The 1914 license plates are enamel, befitting the fancy runabout. Why did the cars have both headlights and carriage lanterns?

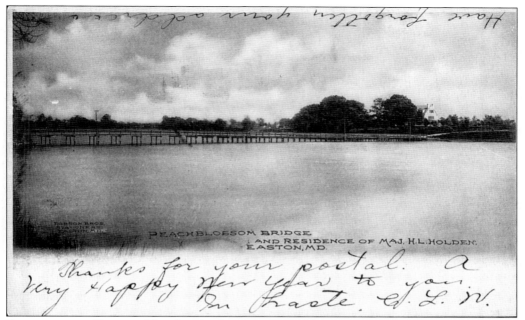

Thanks for your postal. A very Happy New Year to you. In haste. E. L. W.

PEACHBLOSSOM BRIDGE. The first bridge over Peachblossom Creek, on the Oxford Road, was designed, constructed, and partially paid for by Colonel Carroll Goldsborough. In the background is the home of Major H.L. Holden, destroyed by fire in 1918. The area is now the Edgemere development.

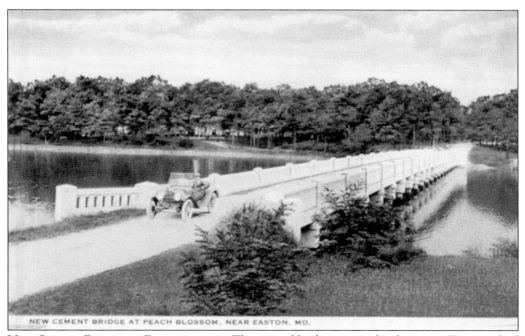

NEW CEMENT BRIDGE AT PEACHBLOSSOM. The second bridge was made of cement. Two cars had difficulty passing, causing numerous accidents.

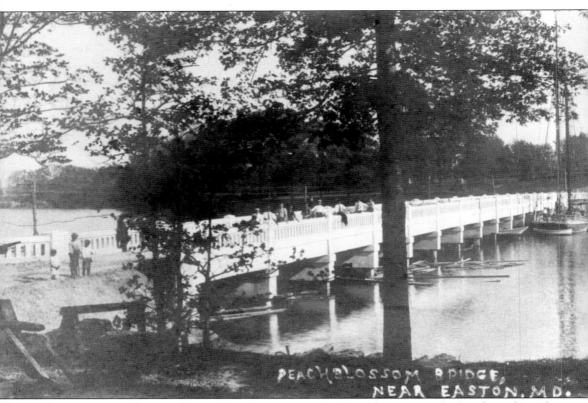

PEACHBLOSSOM BRIDGE. Does this photo postcard show where a car broke through with interested spectators examining the damage, some kind of logging operation, or merely the aftermath of a large storm?

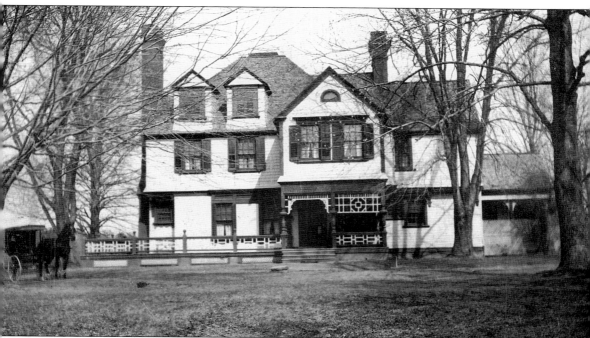

LLANDAFF. John Robinson, who purchased 485 acres on Peachblossom Creek from the estate of Matthew Tilghman Goldsborough, built Llandaff *c.* 1879. The farm passed to Robinson's daughter May, who married John M. Elliott, an avid golfer. The Elliotts were instrumental in founding the Talbot Country Club and sold off waterfront building sites along Peachblossom Creek. The property next passed to the Elliotts' only daughter, Kate, who married William B. Shannahan in Llandaff's parlor on New Year's Eve, 1912. The house and about 10 acres still belongs to May Cecil, one of Shannahan's daughters. (Collection of Robert G. Shannahan.)

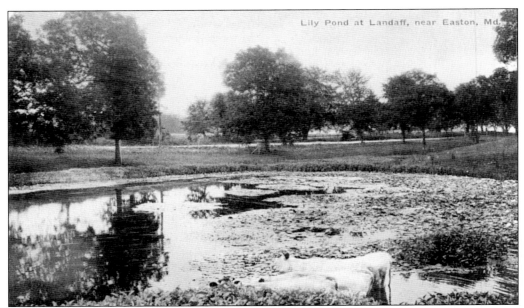

LILY POND AT LLANDAFF. There has always been a lily pond on the Shannahan's property, just after the Peachblossom bridge. Cows enjoyed it in summer and kids in winter when the ice is safer there than on the creek. Above the pond a windmill stands sentinel. The postcard view looks over the Oxford Road, which bends off to the right to follow the third hole of the old Country Club golf course. William E. Shannahan and his son Will have been among the club's golf champions.

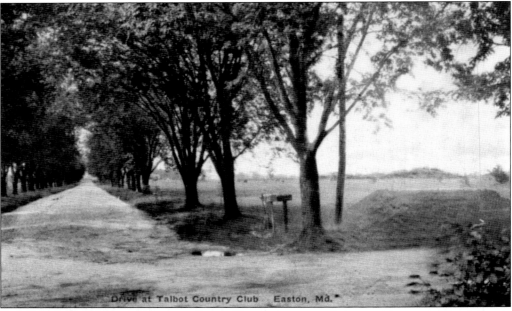

Drive at Talbot Country Club Easton, Md.

THE DRIVE AT TALBOT COUNTRY CLUB. This is the view of the road just past Llandaff as it was in 1918, running along the fairway of the third hole. Notice the fancy elevated tee, behind which was the sandbox used to build sand tees, as wooden tees were not yet in vogue.

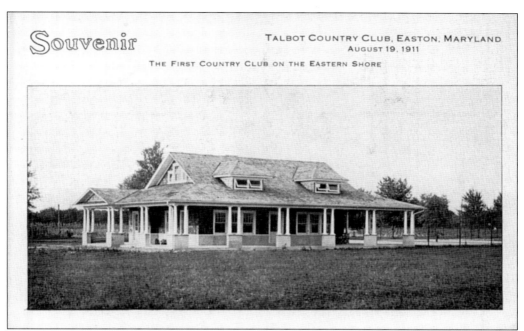

TALBOT COUNTRY CLUB. This "souvenir" card of 1911 calls the Country Club "the first country club on the Eastern Shore." Upstairs were men's lockers with showers; the ladies' room was downstairs. The four tennis courts were the locale of popular tournaments. The two closer courts were replaced in 1950 by a swimming pool.

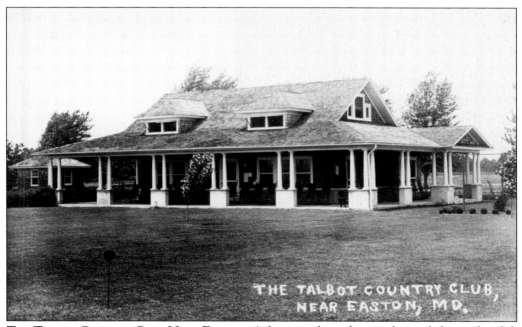

THE TALBOT COUNTRY CLUB NEAR EASTON. A few years later than in the card above, the club had plantings started, and the porch acquired green lawn furniture. A practice putting-green is in the foreground.

115

Easton, Md., Aug 4th 1913

There will be a meeting of the Board of Gover-nors, of the Talbot Country Club at the Club House

at four (4) *p. m.*

on Saturday Aug 9th

H L Holden Jr.

Secretary.

NOTICE OF MEETING. The card reminded the Board of Governors of their meeting. H. Leavenworth Holden Jr., the first secretary, was active in the club's affairs for over 30 years. He lived across Oxford Road on the southeast side and later moved to Old Country Club Road. Tragically, both homes were gutted by fire.

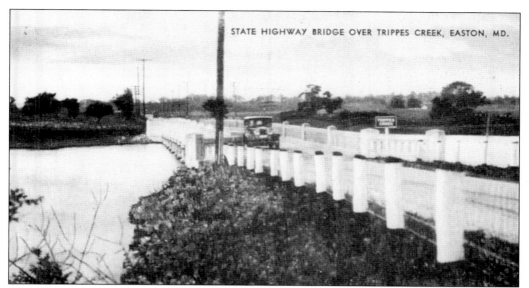

STATE HIGHWAY BRIDGE OVER TRIPPES CREEK. This bridge was another bridge, farther south, on the road from Easton to Oxford. The car was heading south toward Oxford in the year 1930.

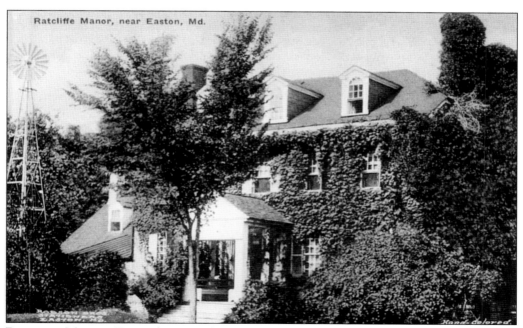

RATCLIFFE MANOR. Two miles west of Easton, one of Talbot's Georgian masterpieces was built in 1757 by Henry Hollyday, whose family was also connected to Wye House, and his wife Anna Maria Robins. The home is beautifully proportioned and in happy relationship to the garden planned along with the house. On its waterfront was the site of Fort Stokes. The farmland surrounding the house is currently proposed for development.

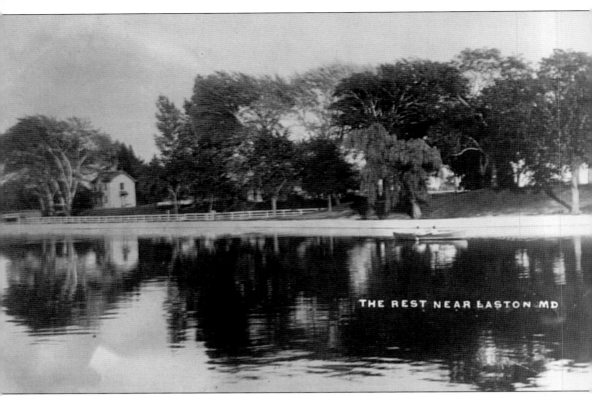

THE REST, NEAR EASTON. The old home of Admiral Franklin Buchanan, A.S.N., Commodore of the *Merrimac*, is located opposite the Anchorage on the Miles River. A calm day on the river was inviting for the rowers.

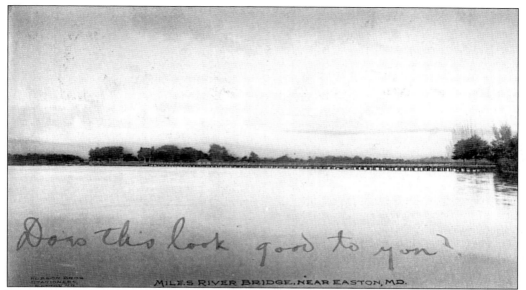

MILES RIVER BRIDGE, NEAR EASTON. This is the oldest postcard view of the bridge, which appears to have wooden pilings and guardrails. There is no draw span visible.

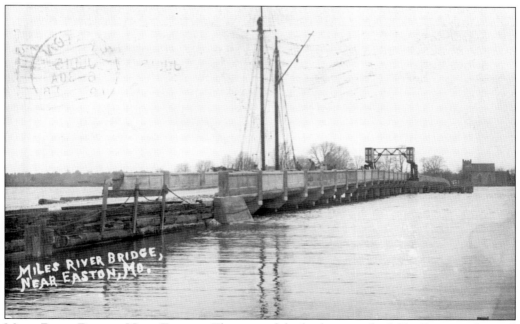

MILES RIVER BRIDGE, NEAR EASTON. The span of the bridge over the Miles River is identical to the crossing of the 17th-century ferry. Several bridges have come and gone since the first toll bridge was built. Draw no longer exists because a new arched modern bridge can give boats with masts clearance. In this scene of around 1915, the old St. Johns Church on the right far shore appears in good condition. Today it is a ruins.

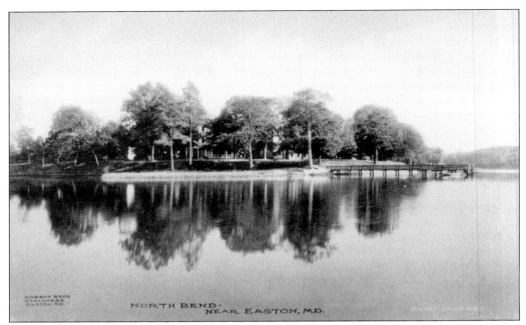

NORTH BEND. There is some Greek, some Italianate, and some Gothic architecture blended in the Miles River residence of the Dixons, an influential Quaker family, whose members were businessmen, railroad presidents, bank presidents, hospital and nursing school founders, and civic philanthropists.

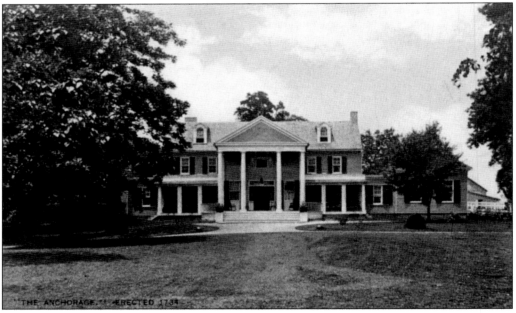

THE ANCHORAGE. On a knoll overlooking the Miles River, this large home began as a small 18th-century brick dwelling, but was transformed by Sarah Lloyd and her husband Lt. Charles Lowndes into an imposing home with two large wings connected to the main section. The house is clearly seen in this card, whereas more often it is screened by trees.

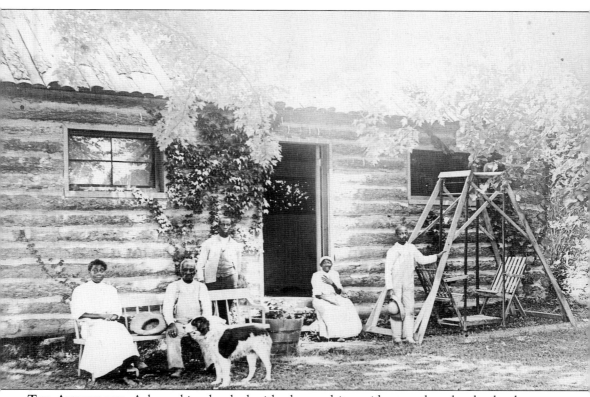

THE ANCHORAGE. A log cabin chunked with clay, and its residents gathered sedately, dates from the early 1900s. It was built by Charles Chipley at the southwest end of the main house.

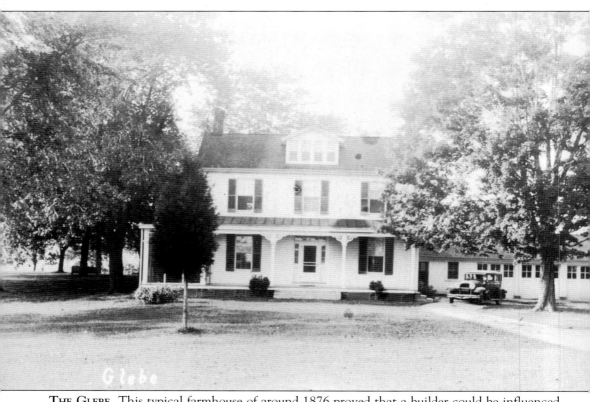

THE GLEBE. This typical farmhouse of around 1876 proved that a builder could be influenced by no particular style at all yet remain true to simplicity and balance. It is standing on Glebe Creek.

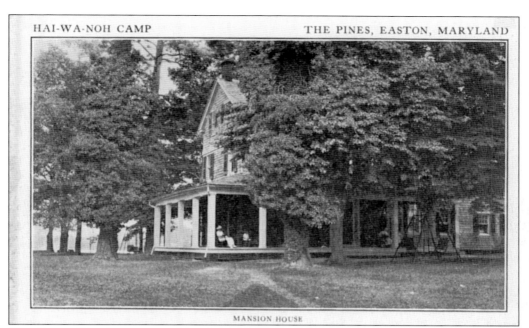

MANSION HOUSE

THE PINES. This home, owned by Guion Miller and later U.S. Congressman Edward Tylor Miller, was also the setting of a summer camp run by the Millers. Guy Miller, a lawyer for the Bureau of Indian Affairs, gave the camp the name Hai-Wa-Noh. Its location is across Glebe Creek from the Villa.

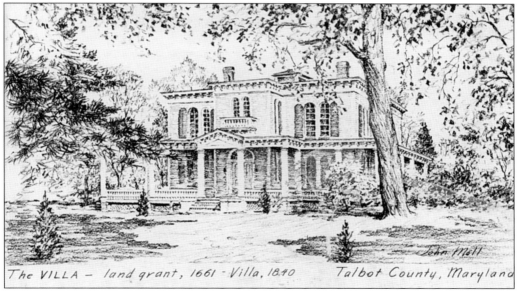

The VILLA — land grant, 1661 - Villa, 1840 Talbot County, Maryland

THE VILLA. This house has gone, but once stood at the confluence of Glebe Creek and Miles River, a magnificent example of Italianate influence with elaborate features and a handsome garden. A three-tiered fountain from those gardens now refreshes a corner of Idlewild Park planted by the Talbot Garden Club. The John Moll card was given at a reception of the Talbot County Historical Society in 1954 when the house was extant.

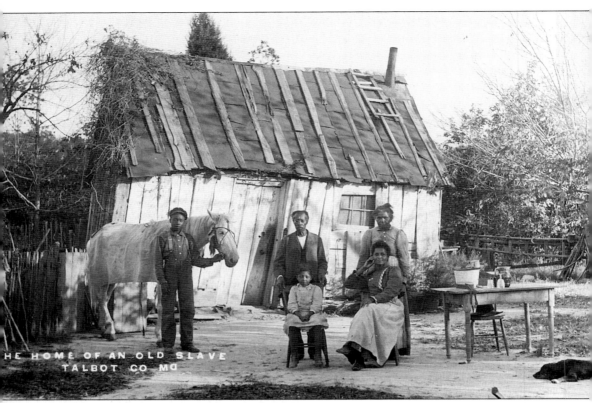

HOME OF AN OLD SLAVE. A home on Glebe Road at the entrance to The Pines was once lived in by slaves, or so the card says. This family posed with an air of independence and dignity. The dog seems unperturbed.

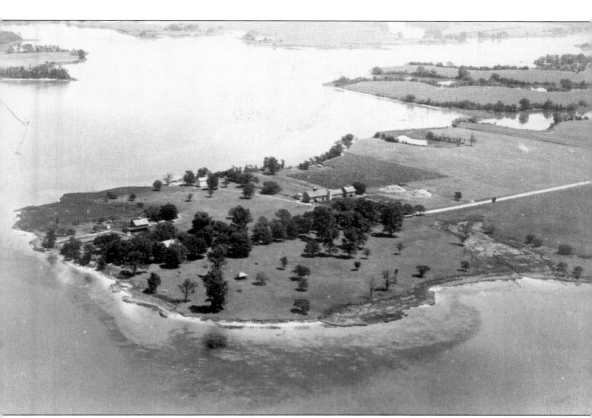

ENNISKILLEN (MARSHY POINT). How land and water intertwine can be seen in this aerial view of a farm at the end of Bailey's Neck. Cedar Point is seen in the distance as the Tred Avon River winds toward Easton Point at the upper left, and Peach Blossom Creek branches right. The clean appearance of lawns and shoreline was caused by the grazing sheep.

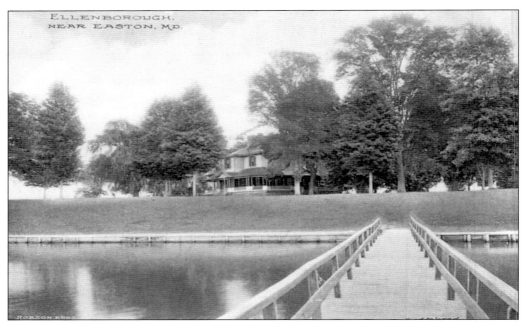

ELLENBOROUGH. Bulkheading constructed on the Tred Avon River shoreline of Ellenborough was rare in 1910, but is now commonplace. Matthew Tilghman Goldsborough built this home in 1859 and named it for his wife, Eleanor Sarah Tilghman. In 1905, its 236 acres were sold to Charles Nickerson for $30,000.

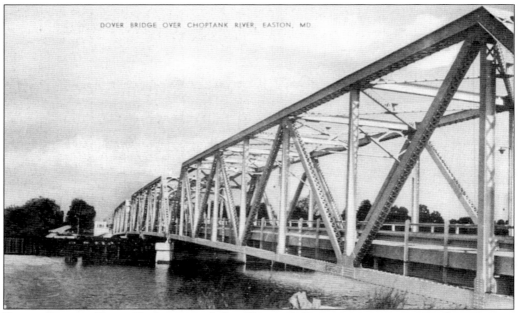

DOVER BRIDGE. Dover Bridge crossed the Choptank River connecting to Caroline County and the ocean beaches. It looked like this in 1930; today it is the center of controversy about whether the creaking drawbridge mechanism should be replaced, and how replacement should be accomplished.

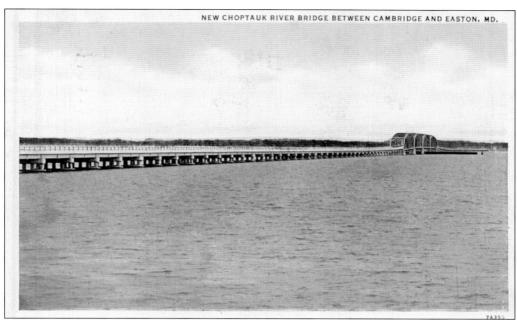

NEW CHOPTANK RIVER BRIDGE BETWEEN CAMBRIDGE AND EASTON. When this "new" bridge was built in 1934, President Roosevelt attended the dedication on his yacht. The newer Fred Malkus Bridge, which replaced this one in 1988, has a rise that eliminates the draw span, but a portion of the original roadway remains a fishing pier.

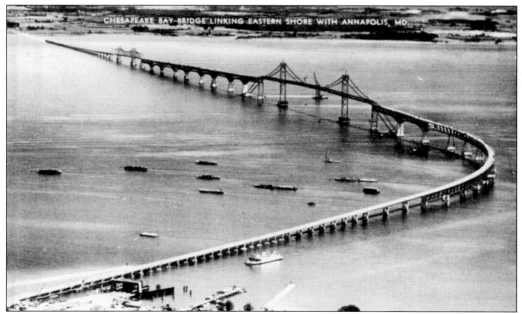

CHESAPEAKE BAY BRIDGE. The bridge, when it was built in 1952, was the first road link across the bay between eastern and western shores. At that time, it was opposed by a majority of the people on the Eastern Shore. The Sandy Point ferry can be seen in the foreground approaching its western terminus.

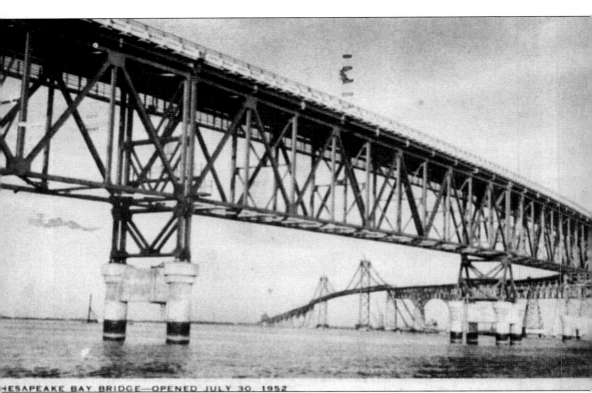

CHESAPEAKE BAY BRIDGE—OPENED JULY 30, 1952

CHESAPEAKE BAY BRIDGE. The bay bridge, dedicated July 30, 1952, changed the sleepy country life of the Eastern Shore. Across it came the world heading for ocean and shore, discovering on its way the small beauties and great pleasures of the land, buildings, and people seen in these postcards.